Understanding Color

Understanding Color

An Introduction for Designers
Second Edition

Linda Holtzschue

John Wiley & Sons, Inc.

Designed by: Jenn Perman
Illustrations by: Jenn Perman and Michelle Barzilay

Library of Congress Cataloging-in-Publication Data:

Holtzschue, Linda.
 Understanding color : an introduction for designers / Linda Holtzschue.—2nd ed.
 p. cm.
 Includes bibliographical references and index.
 ISBN 0–471–38227–2 (paper : alk. paper)
 1. Color in design. I. Title.

 NK1548 .H66 2001
 701'.85—dc21
 2001024025

Printed in the United States of America.
10 9 8 7 6 5 4 3

Contents

Acknowledgments

The second edition of *Understanding Color* would not have been possible without the illustration and design skills of Jenn Perman, who began work on this book as a Fashion Institute of Technology student and finished it as a graduate. My special thanks to Michelle Barzilay, whose contribution to the illustrations was invaluable, and to Professor Joan Lombardi of Fashion Institute of Technology, who not only supervised the book design but also directed me to Jenn and Michelle. My thanks to Professor Ron Lubman of Fashion Institute of Technology, color expert extraordinaire Kenneth Charbonneau, Scott Lethbridge of Elizabeth Eakins Carpets, and Pantone, Inc. for their generous contributions to the illustrations, as well as to Sanderson and Osborne and Little, who were kind enough to allow publication of their wallpaper designs.

Preface

A poor product, colored well, will often sell. A great product, poorly colored, will not move from the shelves.

This is a book for everyone who uses color. It was written for design students and sign painters, architects and carpet salespeople, graphic designers and magicians. It is a road map through the mysteries of color and a guide to using color freely, comfortably, and creatively without dependence on complicated theories or systems. This is a book about learning to see.

An Introduction to Color Study

The Experience of Color / Color Awareness / The Uses of Color /
Color-Order Systems / Color Study

Color is essential for life.[1]
— Frank H. Mahnke

Color is stimulating, calming, expressive, disturbing, impressional, cultural, exuberant, symbolic. It pervades every aspect of our lives, embellishes the ordinary, and gives beauty and drama to everyday objects. If black-and-white images bring us the news of the day, color writes the poetry.

The Experience of Color

Color is, first, a sensory event. The beginning of a color experience is a biological response to the stimulus of light. The colors of the real world—of printed pages, objects, and the environment—are seen as reflected light. Images on a monitor screen are colors seen as direct light.

Colors, whether they are colors of light or colors of objects, are mysteriously unstable— they seem constantly to change. Much of the work of the design industries is done in images of direct light, on a monitor, for products that will ultimately be produced as objects or printed pages. Which is the "true" color—the one seen on the screen, or the one that is experienced as the object? Are they the same color? *Can* they be the same color? Is there such a thing as a "true" color at all?

Light is the cause of color, colorants are the means used to create color, and the color that we see is the effect. The effect of a color changes whenever there is a change in colorant or in light. In addition, colors change according to their placement. Forms, colors, and their arrangement are foundation elements of design. The way in which colored forms are arranged—their placement in relation to each other—also modifies how colors are seen (and the reverse is equally true; colors modify the way we understand forms and their arrangement). This means that every change in light, colorant, form, or arrangement has the potential to change the way a color is perceived. Colors are inherently dynamic, changing in every new situation and with every new use.

[1] Mahnke, Frank H. and Rudolf H Mahnke. *Color in Man Made Environments*. New York: VNR, 1982, page 8.

Designers *use* color. They are concerned with effects, not with causes. Understanding the basics—what we see, and how and why we see it—is only part of the story of color. Understanding how colors "work" is background knowledge that supports the *art* of color. Designers who work with color every day do so in a comfort zone; a healthy mix of fact, common sense, and intuition. We understand color in much the same way that we understand the shape of the earth. The earth is round, but we experience it as flat, and act on it according to that (practical) perception of flatness. Color is light alone, but we experience it so directly and powerfully that we believe our eyes. Color problems in the design industries are solved with the human eye. No matter what technical aids are used, final color decisions are made by human eyes alone. Designers work with color from the evidence of their eyes.

Color Awareness

Color is sensed by the eye, but the *perception* of color takes place in the mind, and not always at a conscious level. Color is experienced at different levels of awareness depending on how and where we see it. Color is understood in context: as form, as light, as surroundings. Color permeates the environment, appears as an attribute of objects, and communicates without words.

Environmental color is all-encompassing. The natural world immerses us in colors, whether they are the cold whites of Antarctica or the lush greens of tropical forests. Manmade environments also surround us with colors. The accidental color compositions of urban streets are as much an immersion in color as the controlled-color environments of architecture, landscape design, interior design, or theater design.

Environmental colors have a powerful impact on the human body and mind, but few people are consciously aware of colors around them. Environmental color is noticed only when it is a focus of attention, like a beautiful sunset or a newly designed room. Most of the time surrounding colors are experienced with an astonishing lack of aware- ness. Someone who states flatly that he "hates green" will nevertheless take enormous pleasure in a garden, describing it as a "blue" or "yellow" garden, when in fact the surroundings are overwhelmingly green, with blue or yellow present in a very small proportion to the whole.

Graphic colors are the colors of images in any medium: painted, drawn, printed, or

on-screen.[2] Graphic art is a powerful form of nonverbal communication. Graphic art informs: it tells a religious story, sends a sales pitch or political message, communicates an emotion, even illustrates an idea about "pure design." The colors of a graphic image are an integral part of the message. Because they are part of a larger idea, the colors of graphic art are experienced on many levels—conscious and unconscious, sensory and intellectual—at the same time.

The colors of objects are perceived very directly. The separateness of an object allows the viewer to focus both eye and mind on a single entity and a single color idea. We are the most consciously aware of color when it is a quality of a defined object: a red dress, a blue car, a yellow diamond.

The Uses of Color

Color is recognized universally as a natural component of beauty. The word for red in Old Russian is synonymous with the word for beautiful (Red Square is *beautiful* square). Colors are used to create beauty; more than that, they are *useful*. Designers use color not only to communicate, but also to manipulate perception, to create focus, to motivate actions and alter behavior, and to create continuity. Among its many uses:

Color can be used as pure function, to reflect or absorb light.

Color is a visual language. Colors can alert or warn; they can be used to convey mood or to express emotion. Intense colors and strong contrasts communicate action and drama. Gentle colors and soft contrasts convey serenity.

Color identifies. It provides instant discrimination between objects of similar or identical form and size. The red file holds unpaid bills; the green file the paid ones.

Color can be used to modify the perception of space. It can create illusions of size, nearness, or distance. Color can minimize or obscure objects and spaces, or be used to delineate space; to separate one area from another.

Color can be used to generate an emotional response. Colors can be selected to stimulate, or to calm. Color has physiological effects on the body. It can be used to arouse a nonvisual sense, instill unconscious motivation, alter behavior, or induce mood.

[2] "Graphein," the Greek root of the English word "graphic," means both "writing" and "drawing."

Color is associative. The most ordinary items of everyday life are identified by color associations. When Mary asks John to look up something in the yellow pages, he has no need to ask what or where those pages are.

Color is symbolic. It can represent a product, an institution, a nation. Cultures use color to symbolize and communicate social status: brides wear white in western Europe, red in India. We mourn in black in the West. In India, mourners wear white. Catholic priests wear black, Tibetan lamas saffron yellow. In ancient China, the emperor alone wore yellow.

Color can be used to create continuity between separated elements in design.

Color can be used to attract the eye, establishing emphasis or focus in composition.

Color suggests. It is impressional. An abstract composition of blurred blues and greens suggests water, not a desert scene. Moonscape colors are never mistaken for those of Monet's garden.

Color-Order Systems

One way to understand color is to organize it into a system; to hypothesize (and illustrate) a structured model of color relationships. The color-order model is a thread that runs from the very earliest writings on color to the absolute present; to tomorrow. Someone always has had, will have, plans to have a new, positively definitive, absolutely true, undeniably logical, *right* way to organize color. But color is such an enormous topic that no single color-order system can be truly useful. Color-order systems that attempt to be too comprehensive do not succeed. In the early 1930s, The National Bureau of Standards tried to categorize and describe 10 million colors for scientific and industrial use. The result was a massive color-name volume and a breathtaking failure. The group "grayish-yellowish-pink," for example, included about thirty–five thousand samples (Sloane 1989, page 23). More successful systems address a narrower range of issues. These systems fall fairly neatly into three groups:

> *Technical-scientific color-order systems*
> *Commercial color-order systems*
> *Intellectual-philosophical color-order systems*

Technical-scientific systems lie in the province of science and industry. They measure color under limited conditions. Most deal with the colors of light, not the colors of objects. One technical means of measuring the color of light is by determining the exact temperature in degrees Kelvin (K) of a special piece of metal, called a blackbody, as it heats up. The color of a blackbody changes at specific temperatures. *Color temperature* refers to the point in degrees K at which the blackbody changes color (emits colored light) as it heats, from yellow, to red, to blue, to white.

The International Commission on Illumination has developed a color triangle that locates mathematically the color (in degrees K) of any light source. Another system, the Color Rendering Index (CRI), addresses both objects and light sources. It evaluates the way in which a given light source renders the colors of objects in comparison to a chart of eight standardized pastel colors.

Although the information provided by technical-scientific color systems is extremely accurate, little of it is useful to artists or designers, even in characterizing how "natural" or "unnatural" colors will appear. These systems of color organization have little application to the day-to-day work of the design studio, although they can be of enormous use in ensuring quality control in manufacturing.

Commercial color systems are familiar to everyone. They are the systematic arrangements of colors that exist to assist users in making selections from the range of colors that is available in a particular product line. Thousands of commercial color-sample systems are available to artists, designers, and the general public. These systems don't claim to include all possible colors, but attempt to include enough to meet most needs within that product (or industry). Paint charts are color-sample systems. Charts of printer's inks, wood stains, clothing catalog fabrics, leather goods, window blind materials, floor coverings—all are color-order systems devised to help the user make a selection.

Commercial color-order systems are practical both in intent and in fact. They do not contribute to an understanding of color, but they were never intended to do so. They offer a limited sampling of colors in a finite number of color families. Within their limits they are useful tools and first-class aids in specifying colors for design.

Intellectual-philosophical systems explore the meaning and organization of color. Great treatises on color have been written by painters from Leonardo DaVinci to Wassily

Figure 1–1 *The Pantone Matching System*® is a commercial color-order system. It provides a palette of standardized colors for a wide range of products, ranging from printers inks to software, color films, plastics, markers and textiles, among others, for use by designers and manufacturers.[3]

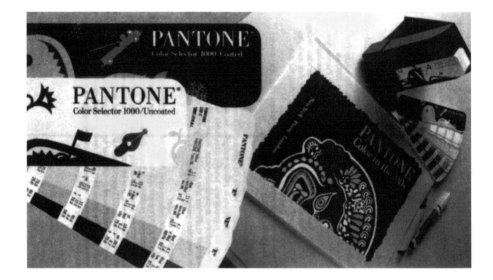

Kandinsky, but a fascination with color has never been limited to artists. Plato and Aristotle wrote on color; their works were known during the Renaissance; Goethe and Schopenhauer wrote on color in the nineteenth century. But the greatest explosion of interest in color began in the intellectual ferment of the late seventeenth century, and the early eighteenth century saw a flowering of color writing that persists to the present day. Two threads of inquiry run through these studies: first, the search for a perfect color-order system; second, the search for laws of harmony in color combinations. The two paths have converged into the present-day field of study known as *color theory*.

Early writers made no distinction between the art of color and the science of color. The colors of light and the colors of objects were dealt with as a single discipline. The natural sciences developed quickly into separate areas: biology, mathematics, physics, chemistry, and later, psychology, among others, but even color theorists whose focus was the arts continued to approach their topic as an aspect of science. The aesthetic and philosophical color-order systems they proposed were viewed as scientific information until well into the twentieth century.[4] Today, writers on color still come from scientific, artistic, and philosophic disciplines, but color theory for artists and designers has been separated from science. Color theory has, at last, its own place in the arts.[5]

Color Study

It make no difference whether color is seen as pure light on a monitor screen or as an attribute of a physical object. No matter how color is seen, or in what medium it is rendered,

[3] PANTONE® and other Pantone, Inc. trademarks are the property of Pantone, Inc.

[4] A scientific premise is tested repeatedly for consistency. If it can be demonstrated invariably to be true, it becomes scientific law. Concepts in the arts can be observed and reported but cannot be proven true in the same way.

[5] *See* Chapter 6, "Color Harmony/Color Effect."

the primary experience of color is *visual*. Color study focuses first on *eye-training*: the visual experience of color.

The second focus of color study is color *control*. The instability of colors cannot be eliminated, but it can be minimized. Designers deal with the instability of color in two principal ways: first, by understanding and adjusting for color changes that occur when colors are seen under different lighting conditions; and second, by understanding and adjusting for the color changes that take place when colors are given different placements relative to one other.

Finally, color study provides guidelines that enable designers to create consistently effective color combinations. There will never be new colors, but there will always be infinite numbers of ways to combine them. The ability to use color effectively is a skill that can be taught and strengthened. Color competence is the ability to predict and control (to the extent possible) color effects. It is also the ability to generate color combinations that respond to the central issue of color in design:

What makes a group of colors work together to solve the problem at hand?

Most color courses taught today have their foundation in the teachings of Albert Munsell (1858–1918) and Josef Albers (1888–1976). Munsell's method follows the classic color-order tradition. It is a formal system based on orderly progressions of hue, value (dark and light), and saturation (vivid versus dull). Albers took a more free-spirited approach. He believed that true understanding comes from an intuitive approach to color. He rejected the formality of color-order systems and stressed the power of eye-training exercises.

The Albers intuitive approach dominates American color education today. Detached from its background in color-order systems, it is not as accessible an approach to teaching color as it can be. The intuitive approach makes infinitely more sense when it follows an understanding of what color-order systems are about. By learning first to discriminate hue, value, and saturation, and mastering the idea of intervals, students acquire skills that make the Albers exercises comprehensible from the start. Color-order and the Albers intuitive approach are not alternative ways to study color, nor are they competitive. The first leads seamlessly to the second, and together they embrace an understanding of color without limits or gaps.

Because color perception is influenced by forces of physiology and psychology, and no two individuals see or share the exact idea of any given color, it's easy to conclude that color study in a class would be (at best) a waste of time or (at worst) a scheduled free-for-all. But there are great benefits from studying color in a group. For every problem assigned there are wrong answers, but there are also many different possible right answers. Twenty students may bring in twenty different yet equally acceptable solutions to the same color problem.

Academic (non-design) education tends to reward students who find the single "right" answer to a question or assignment. The possibility of many right answers for each problem is extraordinarily liberating because it increases exponentially the chances of success. It is also extraordinarily instructive, because seeing a variety of responses, even "wrong" ones, sharpens developing critical skills.[6]

The first goal in color study is to enable the student to see colors without the interference of preconceived ideas. Students with a (self-assessed) "good sense of color" may feel inhibited, disoriented, or exasperated at the start. Just as mastering written music may at first slow down a natural musician, learning basic color skills may at first hamper an artist or designer, but the inhibiting effect is short-term. There is a moment when learned material becomes reflexive, like the magical moment for children when learning to read ends and reading begins. The ability to control effects and create with color is artistic empowerment. The designer who understands color has a competitive edge in every industry.

REFERENCES

Albers, Josef. 1963. *Interaction of Colors*. New Haven: Yale University Press, 1963.

Birren, Faber. *Principles of Color*. West Chester, PA: Schiffer Publishing Company. 1987.

Goethe, Johann von Wolfgang. *Goethe's Color Theory*. Translated by Rupprecht Matthei. New York: Van Nostrand Reinhold Company, 1971.

Hope, Augustine and Margaret Walch. *The Color Compendium*. New York: Van Nostrand Reinhold Company, 1990.

Itten, Johannes. *The Art of Color*. Translated by Ernst Van Haagen. New York: Van Nostrand Reinhold, 1960.

Itten, Johannes. *The Elements of Color*. Edited by Faber Birren. Translation by Ernst Van Haagen. New York: Van Nostrand Reinhold, 1970.

[6] Some students who have been very successful in traditional academic areas find this flexible standard of "rightness" very difficult!

Mahnke, Frank H. and Rudolf H. Mahnke. *Color in Man Made Environments*. New
 York: VNR, 1982.

Munsell, Albert Henry. *A Grammar of Colors*. New York: Van Nostrand Reinhold, 1969.

Nicolson, Marjorie Hope. *Newton Demands the Muse*. Princeton, NJ: Princeton
 University Press, 1966.

Ostwald, Wilhelm. *The Color Primer*. New York: Van Nostrand Reinhold, 1969.

Rodemann, Patricia A. *Patterns in Interior Environments: Perception, Psychology and
 Practice*. New York. John Wiley & Sons, Inc., 1999.

Sharpe, Deborah. *The Psychology of Color and Design*. Totowa, NJ: Littlefield, Adams
 and Company, 1975.

The Color Theories of Goethe and Newton in the Light of Modern Physics. Lecture held in
 Budapest on April 28, 1941, at the Hungarian Club of Spiritual Cooperation.
 Published in German in May, 1941 in the periodical *Geist der Zeit*. English translation
 courtesy of Dr. Ivan Bodis-Wollner, Rockefeller University, New York, 1985.

A Little Light on the Subject

A Little Light on the Subject

Color is a single-sensory experience; a sensation of light that cannot be verified by the other senses. A colored *object* can be touched, but it is the object itself that is tangible, not its color. An object in the dark is a physical entity whose color no longer exists. Color has no physical substance.

Colors are not only intangible, they are also continually changing. Everyone has experienced buying an article of clothing and arriving home to find that it's a different color than it seemed to be in the store, or selecting a paint color and being astonished at the final result. Even the *idea* of a color is unstable. A number of people looking at the same thing often disagree about exactly what color it is.

The instability of color has a number of causes. The first of these is the way in which color is generated by light, reflected from surfaces, and sensed by the human eye. A color of an object is no more permanent or absolute than the light in which it is seen.[7]

Light

Only *light* generates color. Without light, no color exists. Light is *visible energy* that is emitted by a light source. A light source can be any one of a number of things: the sun, a luminous panel, a neon sign, a light bulb, or a television or computer monitor. The eye is a sense organ that is adapted to "receive" light. The retina of the eye receives the energy signal and transmits it to the brain, where it is identified as color.

Light sources emit this visible energy in pulses (or waves) of energy. All light travels at the same speed, but waves of light energy are emitted at different distances apart, or *frequencies*. The distance between the peaks or waves of energy emission is called *wavelength*. Wavelengths of light are measured in nanometers (nm).

[7] The second cause of apparent color change is placement. Color change by placement is addressed in Chapters 3, 4, and 5.

The human eye is able to sense wavelengths of light ranging from about 380 nm to about 720 nm. Certain wavelengths are sensed as discrete (separate) colors: red, orange, yellow, green, blue, indigo (blue-violet), or violet. Red is the longest visible wavelength (720 nm), followed in order by orange, yellow, green, blue, indigo and violet, the shortest visible wavelength (380 nm). These are the colors of visible light, or the *visible spectrum*. ROYGBIV is an acronym for the visible wavelengths: Red, Orange, Yellow, Green, Blue, Indigo, and Violet. (*See* Figure C–2 in color insert.)

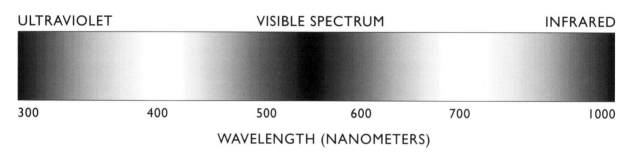

Figure 2–1 *Visible Light.*
Human beings are able to sense light (visible energy) from about 380 nm to 720 nm. There is visible light—and color—beyond the range of human vision.

Visible light does exist beyond the range of human vision There are animals and insects that can sense colors beyond the range of human vision, and both ultraviolet and infrared (colors that lie beyond the two ends of the visible spectrum) can be made visible to the human eye with special optical equipment.

Mixing Light: Additive Color

The sun is our fundamental light source. Sunlight is sensed as white, or colorless, but it is actually made up of a mixture of colors. The colors can be seen separately when sunlight is passed through a prism. The prism refracts (bends) each wavelength at a slightly different angle, and each component color emerges as a separate beam.

Other sources, like lamps (light bulbs), also produce white light. A light source does not have to emit all of the visible wavelengths in order for white light to result. White light is produced when a source emits the red, green, and blue wavelengths in roughly equal proportions. *Red, green, and blue are the primary colors of light.* A source can emit additional wavelengths (colors) and its light will remain white, but if any one of the three primaries is missing, the light will be sensed as a color, not as white.

Mixing two primary colors of light produces a new color. Blue and green wavelengths

combined produce cyan (blue-green). Red and blue wavelengths combined produce magenta (a blue-red, or red-violet), and green and red wavelengths combined produce yellow. Cyan, magenta and yellow are the secondary colors of light.[8] (*See* Figure C–3 in color insert.)

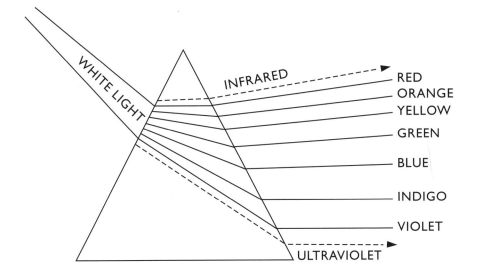

Figure 2–2 *The Component Wavelengths of White Light.* The individual wavelengths (colors) that make up white light can be seen by passing light through a prism. As the light passes through the prism, each wavelength is bent at a slightly different angle and emerges as a separate color.

Wavelengths can be combined in unequal proportions to produce additional colors. Two parts green and one part red result in yellow-green; two parts red and one part green produce orange. Brown light can be produced by mixing one part blue, one part green, and four parts red. All hues, including the violets or purples that are not found as wavelengths in the visible spectrum, can be produced in light by mixing primary colors in different proportions.[9]

White or colored light seen as a result of a combination of wavelengths is called an *additive mixture or additive color.* Either term is a good description of the reality, because new colors of light are produced as wavelengths are added to each other.

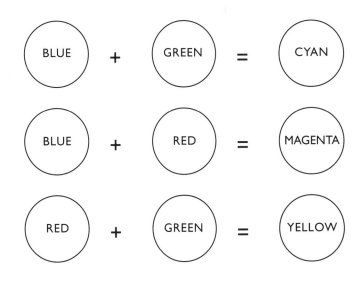

Figure 2–3 *Mixing Light.* The light primaries, red, green, and blue are mixed to form the secondaries cyan (blue-green), magenta (blue-red), and yellow.

[8] Two secondary colors of light mixed together will also produce white light because any pair of secondary colors contains the three primaries: red, green, and blue.

[9] http://www./bway.net/~jscruggs/add.html

Lamps

Light bulbs are the principal source of manmade light. The correct term for a light bulb is a *lamp*. The fixture that holds the lamp is a luminaire (an ordinary table lamp is technically a "portable luminaire"). There are hundreds of different kinds of lamps, each providing light of a slightly different color, quantity, and direction. The most familiar are the "A-lamp," or incandescent light bulb, and the fluorescent tube.

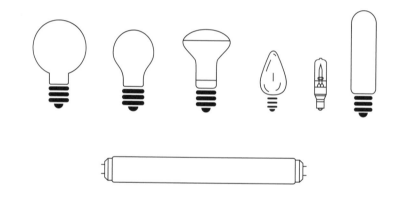

Figure 2–4 *Lamps.* Lamps (light bulbs) are available in hundreds of shapes and sizes.

A lamp that emits only one or a few wavelengths gives off colored light. Neon signs are an example of light emitted in a narrow range of wavelengths. The sodium lamps often used on expressways and in parking lots are another example of light emitted in a narrow band of color. Sodium lamps provide high lighting levels, but the light they emit is yellow.

Figure 2–5 *Additive Color.* Neon signs are a familiar example of additive color, or color seen as direct light reaching the eye.

combined produce cyan (blue-green). Red and blue wavelengths combined produce magenta (a blue-red, or red-violet), and green and red wavelengths combined produce yellow. Cyan, magenta and yellow are the secondary colors of light.[8] (*See* Figure C–3 in color insert.)

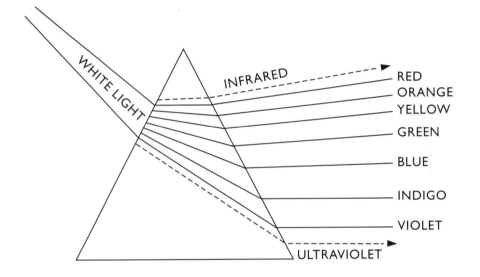

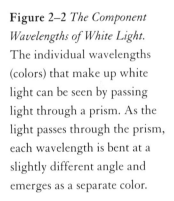

Figure 2–2 *The Component Wavelengths of White Light.* The individual wavelengths (colors) that make up white light can be seen by passing light through a prism. As the light passes through the prism, each wavelength is bent at a slightly different angle and emerges as a separate color.

Wavelengths can be combined in unequal proportions to produce additional colors. Two parts green and one part red result in yellow-green; two parts red and one part green produce orange. Brown light can be produced by mixing one part blue, one part green, and four parts red. All hues, including the violets or purples that are not found as wavelengths in the visible spectrum, can be produced in light by mixing primary colors in different proportions.[9]

White or colored light seen as a result of a combination of wavelengths is called an *additive mixture or additive color.* Either term is a good description of the reality, because new colors of light are produced as wavelengths are added to each other.

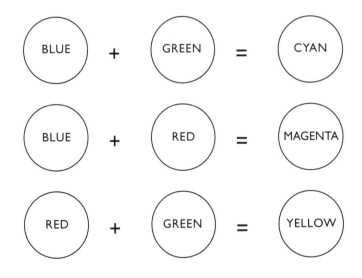

Figure 2–3 *Mixing Light.* The light primaries, red, green, and blue are mixed to form the secondaries cyan (blue-green), magenta (blue-red), and yellow.

[8] Two secondary colors of light mixed together will also produce white light because any pair of secondary colors contains the three primaries: red, green, and blue.

[9] http://www./bway.net/~jscruggs/add.html

Lamps

Light bulbs are the principal source of manmade light. The correct term for a light bulb is a *lamp*. The fixture that holds the lamp is a luminaire (an ordinary table lamp is technically a "portable luminaire"). There are hundreds of different kinds of lamps, each providing light of a slightly different color, quantity, and direction. The most familiar are the "A-lamp," or incandescent light bulb, and the fluorescent tube.

Figure 2–4 *Lamps.* Lamps (light bulbs) are available in hundreds of shapes and sizes.

A lamp that emits only one or a few wavelengths gives off colored light. Neon signs are an example of light emitted in a narrow range of wavelengths. The sodium lamps often used on expressways and in parking lots are another example of light emitted in a narrow band of color. Sodium lamps provide high lighting levels, but the light they emit is yellow.

Figure 2–5 *Additive Color*. Neon signs are a familiar example of additive color, or color seen as direct light reaching the eye.

Most lamps produce white light. They emit the three primary colors of light; red, green, and blue, and most or all of the other colors. A catchall phrase for lamps that emit white light is "*general light source.*" All general light sources, however, do not produce white light that is exactly the same. Each type of lamp emits wavelengths in a characteristic pattern called a *spectral reflectance curve.*[10]

The spectral reflectance curve shows the strength of each wavelength in relation to the others for that particular type of lamp. The curve provides a visual profile of the color characteristics of any source. A lamp may emit one or two of the primaries at a higher level of energy than the others; or additional colors may be emitted strongly, or one or more may be missing entirely. If the wavelengths leaving the lamp were colored ribbons, some of the ribbons would be thicker, wider, and stronger than others.

Spectral distribution determines (and describes) the color quality of a general light source: its warmth, coolness, or neutral whiteness. Differences in spectral distribution cause lamps to produce light that is very "white" (red, green, and blue equally), "warm white" (more yellow or red), or "cool white" (more green or blue). Spectral distribution also determines how a lamp *renders* (shows, or displays) the colors of objects (see below). Every lamp is described technically by its spectral distribution.

Incandescent lamps, like the sun, produce light by burning. The light they emit is a by-product of heat. Also like the sun, incandescent light sources emit the visible wavelengths as a continuous spectrum. Candlelight, firelight, and incandescent lamp-light are sensed as most natural because they emit light the same way the sun does.[11]

The apparent whiteness of an incandescent lamp depends on the temperature at which it burns, called its *color temperature.* Color temperature in lamps is measured in degrees Kelvin (K). Typical incandescent lamps burn at a relatively low temperature, around 2600–3000K, and shed a warm, yellow light. They give off more energy in the red-orange-yellow range than in the blue or green. Lamps that burn hotter emit "bluer" light; "white" light is hottest of all. The heat-light-color relationship is recognized in colloquial language; something that is "white-hot" is dangerously hotter than something "red-hot."

Color temperature is used as a measure of whiteness in a lamp, but it does not describe its spectral reflectance. Two lamps can have similar color temperatures but have different spectral distributions, which means that colors seen under them will appear very differently (*See* Lamps and Color Rendition, below).

[10] Also known as a *spectral distribution* curve.

[11] The scientific concept of color temperature in light sources is unrelated to the color theory concept of warmth or coolness in colors, which is also sometimes called color temperature.

Fluorescent lamps produce light in a completely different way. The interior of the glass bulb is coated with phosphors, which are substances that emit light when they are bombarded with electrical energy. The color of a fluorescent lamp depends on the particular makeup of its phosphor coating. Fluorescent lamps do not burn, so they do not have an actual color temperature, but they are assigned an "apparent color temperature" to indicate their degree of whiteness.

Light from a fluorescent source is not sensed as "natural" in the quite same way as incandescent light. Fluorescent lamps do not produce the continuous spectrum that is characteristic of incandescent light. Instead, they give off light as a series of separate bands of energy. Although fluorescent lamps are available with many different spectral distributions, a typical fluorescent lamp gives off all wavelengths nearly equally.

The human eye is most sensitive to the yellow-green range of light. This genetic predisposition may be an adaptation to the needs of food gathering; to finding the freshest green vegetation. Whatever the reason, given the same energy output at each wavelength, the eye senses yellow-green light as the brightest and red and blue light as the darkest. Because of the eye's sensitivity to yellow-green, a fluorescent lamp emitting the visible wavelengths at roughly equal levels will not appear as a clean white, but as a greenish-white.[12]

A lamp described as "full-spectrum" tells the purchaser only that the lamp emits all wavelengths. It does not describe the strength of those wavelengths relative to each other, or tell whether or not the wavelengths are continuous, or describe the relative warmth or coolness of the white light that is produced.

To refer to light sources as "true," or "natural," or "artificial," is deceptive. It leads to the misconception that there is "true" light and its opposite, "false" light. We think of "natural light" (sunlight) and "artificial light" (from a manmade source) as if they were different entities, but light is always light: visible energy. There are naturally occurring light sources and manmade ones. Every source produces light that can be differentiated from other sources in two ways. The first is by its spectral distribution. The second is by its *apparent* whiteness. Daylight is the standard of whiteness for manmade light sources, and, because response to sunlight is part of our human genetic makeup, it also helps to determine whether light from a given source will be sensed unconsciously as more or less "natural."[13]

The *amount* of light emitted by a lamp is unrelated to its spectral distribution. The same lamp type may give off more or less light, (a 250–watt A-lamp versus one of 75 watts,

[12] In addition to its noncontinuous spectrum and high output in the yellow-green range, light from a fluorescent source is sensed differently because it does not reach the surface at an angle in the same way as sunlight or incandescent light does.

[13] The color temperature of sunlight is variable, measured at noon around 5000K. The whiteness of daylight when used as a standard is measured as an average of its color temperature measured at different locations, elevations, times, etc. (General Electric TP119).

for example), but the pattern of relative energy emitted at the different wavelengths will be identical for that lamp type no matter what quantity of light it gives off.[14]

The ability to discriminate colors is a complex interaction between light source, human perception, and the light-modifying characteristics of materials. The ability to perform most tasks depends on the ability to see the difference between dark and light, not the ability to detect color. Black-and-white photographs and written text are perfectly understandable. The ability to see dark/light contrast is unaffected by lamp color. Only lighting level, or the quantity of available light, affects the ability to see dark and light differences. And although many people report different levels of comfort under a variety of light sources, human performance under general light sources has not been shown to be affected by lamp color, only by lighting levels. [15]

Monitors

A color monitor, or video display terminal (VDT), is also a light source. Monitors emit light as a display of patterns and colors on a screen. The inside of the screen is coated with phosphors, special materials that emit specific colors when excited by electrical energy. The screen coating is made up of phosphors that emit the primary colors of light—red, green, and blue—when they are excited by electrical energy. Light mixed on the screen allows a wide range of colors to be displayed, and the display is experienced as additive color: as direct light to the eye.

Figure 2–6 *A Color Monitor.*
The monitor screen displays images in additive color.

[14] Although the quantity of light emitted by any lamp is not a concern in *lamp* color, the amount of light emitted does affect the viewer's ability to see the colors of *objects. See* Chapter 3, "The Human Element."

[15] General Electric Lighting Application Bulletin #205–41311.

Vision

Vision is the sense that detects the environment and objects in it through the eyes. It is the principal way in which physical realities like objects and the environment are discerned and the only way in which color is perceived.[16] Color vision is experienced in two different ways: either as light directly from a light source, or as light reflected from an object.

In the illuminant mode of vision, colors are experienced as direct light reaching the eye, like the colors of a computer monitor or a neon sign. The tangible things of the real world—objects and the environment—are seen in the object mode of vision. In the object mode of vision, color is seen as reflected light.

The Illuminant Mode of Vision

The *illuminant mode of vision* has two variables in the perception of color: the light source and the viewer. Television and computer monitor displays, traffic lights, and neon signs are examples of the illuminant mode of vision. Colors seen in the illuminant mode of vision are additive colors.

Colors that are seen as direct light are more stable than the colors of objects. Colors of light do not change when the source is moved from room to room, or from darker to lighter surroundings. A specific wavelength (or mixture of wavelengths) is sensed as the same in all situations. The color of light is constant (unless the light source breaks down or changes its pattern of wavelength emission). The individual viewer's perception of color, however, is a singular event. Viewers vary in their ability to sense colors, and, more significantly, they interpret what they have sensed in very different and personal ways.

The Object Mode of Vision

In the *object mode of vision,* color is seen as light reflected from a surface. Physical objects and the environment are seen as reflected light. Color perception in the object mode of vision has *three* variables: the light source, the object, and the viewer. The three variables are so interdependent that if any one changes, the apparent color of that object will also change.

Light leaving a light source is the *incident beam*. When the incident beam reaches a surface, some or all of the light falling on the surface reflects, or bounces, off it. The *reflected beam* is light that leaves a surface and reaches the eye.

[16] Colored light is absorbed through the skin, but without awareness. Color is experienced consciously only through the eyes.

for example), but the pattern of relative energy emitted at the different wavelengths will be identical for that lamp type no matter what quantity of light it gives off.[14]

The ability to discriminate colors is a complex interaction between light source, human perception, and the light-modifying characteristics of materials. The ability to perform most tasks depends on the ability to see the difference between dark and light, not the ability to detect color. Black-and-white photographs and written text are perfectly understandable. The ability to see dark/light contrast is unaffected by lamp color. Only lighting level, or the quantity of available light, affects the ability to see dark and light differences. And although many people report different levels of comfort under a variety of light sources, human performance under general light sources has not been shown to be affected by lamp color, only by lighting levels. [15]

Monitors

A color monitor, or video display terminal (VDT), is also a light source. Monitors emit light as a display of patterns and colors on a screen. The inside of the screen is coated with phosphors, special materials that emit specific colors when excited by electrical energy. The screen coating is made up of phosphors that emit the primary colors of light—red, green, and blue—when they are excited by electrical energy. Light mixed on the screen allows a wide range of colors to be displayed, and the display is experienced as additive color: as direct light to the eye.

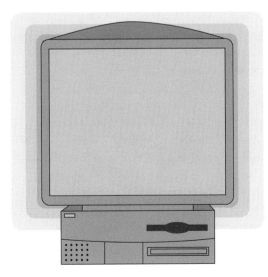

Figure 2–6 *A Color Monitor.* The monitor screen displays images in additive color.

[14] Although the quantity of light emitted by any lamp is not a concern in *lamp* color, the amount of light emitted does affect the viewer's ability to see the colors of *objects*. *See* Chapter 3, "The Human Element."

[15] General Electric Lighting Application Bulletin #205–41311.

Vision

Vision is the sense that detects the environment and objects in it through the eyes. It is the principal way in which physical realities like objects and the environment are discerned and the only way in which color is perceived.[16] Color vision is experienced in two different ways: either as light directly from a light source, or as light reflected from an object.

In the illuminant mode of vision, colors are experienced as direct light reaching the eye, like the colors of a computer monitor or a neon sign. The tangible things of the real world—objects and the environment—are seen in the object mode of vision. In the object mode of vision, color is seen as reflected light.

The Illuminant Mode of Vision

The *illuminant mode of vision* has two variables in the perception of color: the light source and the viewer. Television and computer monitor displays, traffic lights, and neon signs are examples of the illuminant mode of vision. Colors seen in the illuminant mode of vision are additive colors.

Colors that are seen as direct light are more stable than the colors of objects. Colors of light do not change when the source is moved from room to room, or from darker to lighter surroundings. A specific wavelength (or mixture of wavelengths) is sensed as the same in all situations. The color of light is constant (unless the light source breaks down or changes its pattern of wavelength emission). The individual viewer's perception of color, however, is a singular event. Viewers vary in their ability to sense colors, and, more significantly, they interpret what they have sensed in very different and personal ways.

The Object Mode of Vision

In the *object mode of vision,* color is seen as light reflected from a surface. Physical objects and the environment are seen as reflected light. Color perception in the object mode of vision has *three* variables: the light source, the object, and the viewer. The three variables are so interdependent that if any one changes, the apparent color of that object will also change.

Light leaving a light source is the *incident beam.* When the incident beam reaches a surface, some or all of the light falling on the surface reflects, or bounces, off it. The *reflected beam* is light that leaves a surface and reaches the eye.

[16] Colored light is absorbed through the skin, but without awareness. Color is experienced consciously only through the eyes.

Colors seen as reflected light are understood very differently from colors seen as direct light. A classic misunderstanding of that difference took place in the 1970s when many fire engines were painted yellow-green instead of the traditional red. The reason given was that the sensitivity of the eye to yellow-green light made yellow-green the most visible, and, therefore, the safest color. Yellow-green fire engines disappeared very quickly and the traditional red returned, an outcome not of nostalgia but of practical reality. Fire engines are objects, not wavelengths of light. Very different principles of high visibility apply. Red fire engines are more visible than yellow-green ones because red is more likely to contrast sharply with the environment than yellow-green.

Modifying Light: Colorants

Materials are the substance of the real world. They are the "stuff" of physical objects, the things that can be seen and touched. Materials modify light. Light reaching a material is modified in one of three ways:

> *Transmission*: the material allows light to pass through, as through glass.

> *Absorption*: the material soaks up light reaching it like a sponge, and the light is lost as visible. It can no longer be seen.

> *Reflection,* or *scattering*: light reaching a material bounces off it, changing direction.

Colorants are special materials that modify light by *absorbing* some wavelengths and *reflecting* others.[17] Some colorants, like chlorophyll (the green of plants) or hemoglobin (the red of blood) occur naturally. Others are manufactured from natural or synthetic substances. A colorant can be applied to an object, like paint, or it can be an integral part of a material, like a solid-color plastic. Colorants are also called color agents, dyes, pigments, and dyestuffs.

A white colorant reflects all wavelengths of light. A "white" object (an object with a white colorant) placed under a general light source reflects all of the wavelengths reaching it. A black colorant absorbs all of the wavelengths of light. A "black" object placed under a general light source absorbs all wavelengths of light reaching it.

Other colorants modify light *selectively*. A "red" object placed under a general light

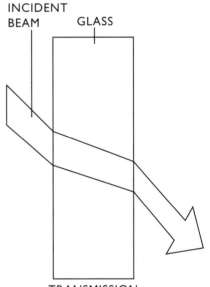

Figure 2–7 *Transmission.*
Window glass transmits light, allowing it to pass through with no perceptible change. Thin glass bends light so slightly that it retains its whiteness.

[17] A second kind of colorant modifies light by absorbing some wavelengths and *transmitting* others. *See* Process Colors in Chapter 7, "Tools of the Trade."

source absorbs all of the wavelengths except red, which it reflects. The red wavelength reaches the eye, and the object is seen and understood to be red.

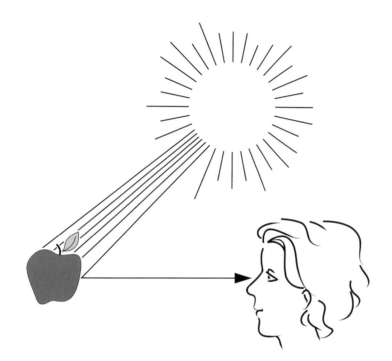

In order for an object to be seen as a color, the wavelengths that its colorant reflects must be present in the light source. If a red object is placed under a source that lacks the red wavelength, all light reaching the object is absorbed. No color is reflected back to the eye. A red dress seen under green light is a black dress. In a parking lot illuminated by sodium lamps, red cars, green cars, and blue cars are indistinguishable from each other. Only yellow cars can be located by their color.

Colorants don't absorb and reflect individual wavelengths perfectly. They may absorb part of a wavelength and reflect part of it, or reflect more than one wavelength. So many possibilities exist that the range of visible colors is nearly infinite. Colors seen as the result of the absorption of light are *subtractive mixtures*. Colorants "subtract," or absorb, some wavelengths. The remaining wavelengths are reflected and reach the eye as color.

Figure 2–8 *Subtractive Color.* A colorant on the surface of a "red" apple absorbs all the wavelengths except red. Only the reflected (red) wavelength reaches the eye, and the apple is seen as red.

Colorants, like lamps, can be compared in a laboratory by measuring their spectral reflectance. Lamps are compared by the relative power of emission at each wavelength. Colorants are compared by their *reflective* power. The reflectance of different colorants must be compared under the same light source. The light source usually used for color comparisons in a laboratory is a Macbeth lamp, which has spectral distribution similar to sunlight. One color sample is designated as a standard and others are measured against it under the Macbeth lamp, using a tool called a photocolorimeter. The ability to measure light reflected from a colorant under controlled laboratory conditions has little practical application for the artist or designer, but it is critically important to quality control in industry.

It's a common misconception that the "true" color of any object can be captured under the correct lamp. The most commonly used light sources are A-lamps, or ordinary incandescent light bulbs, and cool fluorescent tubes. Each is quite different in spectral reflectance from the sun, from the Macbeth lamp, and from each other. A Macbeth

lamp is a laboratory tool, not a readily available general light source. If "true" colors existed, and were visible only under Macbeth lamps or in sunlight, they could be seen only in laboratories and in the outdoors. Science can produce true colors as measurable wavelengths of light and subtractive colors can be matched as true to a given standard, but the color of an object is only as "true" as the viewer chooses to think of it.

Modifying Light: Surface

Surface is the outermost layer of a thing, its "skin." The position of a light source determines the angle at which light reaches an object. The nature of the surface—rough, smooth, or in–between—determines the direction of light leaving it; the *reflected* beam.[18]

The direction of the reflected beam influences how colors are perceived in terms of light and dark. Differences in surface texture have no effect on the actual *color* of reflected light—a rough-skinned object and a smooth one that have the same colorant reflect the same wavelength. But a smooth surface reflects light more directly—and will therefore appear to be a lighter color—than a rougher one.

Smooth surfaces reflect light very directly, so that a good deal of the light falling on them is reflected back to the eye. A *matte* surface is a smooth surface that is very slightly, even microscopically roughened. Its roughness is too fine to be seen with the naked eye. A matte surface diffuses (spreads) light very evenly, so that light leaving the surface is constant from any angle of view. Colors on a matte surface, like an uncoated paper, have a flatness and uniformity that makes them easy to see and to understand.

Textured surfaces reflect light in a more fragmented way. A finely textured surface scatters light in many directions, so that less light reaches the eye. A textured surface appears darker than the same material with a smoother finish. Heavily textured or irregular surfaces scatter light in so many directions that they appear dappled with areas of light, medium, and dark. The dark-light variations of color on a textured surface make it dynamic and lively.

Varying the textures of a surface allows designers to create an effect of two or more colors (or more accurately, lighter and darker versions of a single color) when only one color and material is present. A piece of yarn, seen on its long side, reflects a certain amount of light and wavelength. Cut ends of the same yarn reflect the identical wavelength, but they scatter light more widely, so less light reaches the eye. Textiles woven in a single yarn are made into patterns by alternating areas of flat weave with areas of

[18] *Reflectance* is the amount of light falling on a surface that is reflected back. Reflectance is a measure of the *total* amount of light reflected, not the specific wavelengths (colors). Reflectance is so important to some industries, like paints and printing inks, that the percentage of light reflected back from each color (called its LRV, or light-reflecting value) is part of the basic information the manufacturer provides.

end yarns (called the cut pile, or nap). Embossed materials and "frosted" glassware are other examples of surfaces that are manipulated to create dark and light patterning within a single material and color.

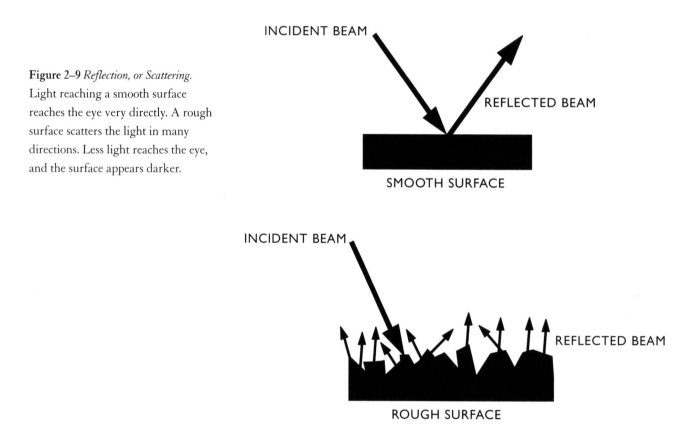

Figure 2–9 *Reflection, or Scattering.* Light reaching a smooth surface reaches the eye very directly. A rough surface scatters the light in many directions. Less light reaches the eye, and the surface appears darker.

Glossy surfaces reflect light very directly to the eye. A *specular surface* is mirror-like. It reflects light so directionally that much of the light reaching it is reflected as white light, and less light reaches any underlying colorant. Specular surfaces are dramatic. They dazzle the eye with sharply directed white light and, at the same time, darken colors by deflecting much of the incident beam before it reaches the colorant. The extreme reflectance of specular surfaces makes it difficult to interpret their color.

Too little available light makes it hard to see colors.[19] Excessive and uncontrolled light can also can impair color perception. Glare is an extreme, physically-fatiguing level of

[19] *See* Chapter 3, "The Human Element."

general light. *Glare* obliterates color perception and is temporarily blinding. Glare is corrected by adjusting the light source: by reducing the quantity of light, changing the direction from which it comes, or both.

High light levels combined with specular surfaces result in a particular kind of glare called a *veiling reflection*. Light that is sharply reflected from glossy materials like coated papers or monitor screens impairs the performance of tasks and interferes with color perception. Veiling reflections have less to do with the quantity of light than the direction from which it comes. They can usually be reduced or eliminated by changing the angle of the light source.

Transparent, Opaque, and Translucent

Some light is always lost when light is transmitted (passes through) a material, but the light loss can be so slight that as a practical matter it's unimportant. If all (or nearly all) of the light reaching an object or material is transmitted, that object is *transparent*. Window glass is an example of transparent material. If all of the light reaching an object is either reflected or absorbed, the object is *opaque*.

When some of the light reaching an object or material is transmitted and some is reflected, the object is *translucent*. A translucent material can be white or a color, depending on its selective transmission and reflection of the various wavelengths. Translucent materials may allow a great deal of light to pass through (and be very translucent) or transmit very little light (and be barely translucent).

Lamps and Color Rendition

General light sources vary widely in their ability to render the colors of objects. The same object will change in color under a variety of light sources because of differences in the spectral reflectance of each source.

Making color choices under one set of light conditions for use under a different set of lighting conditions can be a disaster. A woman wearing astonishingly bright red makeup has probably applied her cosmetics under cool fluorescent lighting. Because of the weakness of the red wavelength in standard fluorescent lamps, enormous quantities of the colorant—the makeup—must be applied to get a visibly red result. Seen in incandescent light or daylight, the red is overwhelming.

Fluorescent lamps are specified for commercial lighting because they provide high light output, low heat, and low operating cost. Fluorescent lamps emit a relatively low level

of red wavelength, so items with red colorants receive little red light to reflect. Vendors are aware of this weak spot in the color rendition of standard fluorescent lamps. Cosmetics counters provide separate light sources for sampling colors, and grocers choose lamps with stronger red component for use over meat counters to ensure that products appear fresh and healthy.

In residential interior design, considerations of lamp color (and the resulting color rendition) usually take precedence over light output and cost. Incandescent lamps are nearly always chosen over fluorescents as a general source. Lamps can be selected for color adjustment or correction in completed interiors. Colors selected in daylight may be too warm or too cool for night lighting. Red-orange schemes can be muted by using a lamp with a weaker warm range; color schemes that are too blue or green can be muted by using lamps with stronger output in the red-orange-yellow range. Conversely, lamps can be chosen to enhance colors. Some manufacturers even recommend specific lamps for different situations: one type for warm color schemes, another for cool ones.

Lamp choices for commercial applications (including such crucial areas as studio work spaces) are frequently made for light output and energy efficiency without consideration of color rendering qualities. Poor quality color rendering that results from poor lamp choice is equally problematic for designers, manufacturers, retailers and consumers, because for most products, from foods and flowers to cosmetics and carpets, good color presentation is critical to sales.

Metamerism and Matching

Two objects that appear to match under one light source but not under another exhibit *metamerism*. The objects are called a *metameric pair*.

Materials differ in their ability to absorb colorants or accept them as coatings. The substance used as a blue colorant for wool may have little or no relationship to one used to produce a similar blue in cotton. Other substances are used as blue colorants for plastics, glass, paint, or ceramic dinnerware.[20]

Each colorant, no matter what material it colors, reacts to light in a very specific way. If the colorants or substrates (underlying materials) of two things are different, they cannot be made to match under all light conditions. Two red-dyed cottons may appear to match exactly under incandescent lighting. If their dyes are different, one dye may be more red-reflective than the other. When the two cottons are placed under a fluorescent lamp

[20] Textiles dyes and the fibers that absorb them are said to have dye affinity. A process called cationic dyeing illustrates the creative possibilities of dye affinities. Fabric is woven into a pattern using two or more different, undyed fibers—like rayon and cotton. No pattern can be seen in the undyed state. The fabric is dipped into successive dye baths, each with an affinity for one of the fibers. The pattern becomes visible only after dyeing. The production cost advantages are twofold: many different trial sample colorways can be produced without re-setting a loom, and a number of colorways can be produced from the same undyed (or "greige") goods.

that is weaker in the red wavelength, the cotton with the more red-reflective dye appears brighter and "redder" than the other.

So-called "matching" wallpapers and fabrics, or silk shirts and wool skirts, or china sinks and enameled cast iron bathtubs, can never truly match because both their underlying materials and colorants are different. What is possible and practical is to reach an acceptable match, one that is pleasing to the eye. When different materials must reach an *acceptable match*, it is essential to compare them under lighting conditions that duplicate their end placement.

Many manufacturers control acceptable match in related goods by maintaining color laboratories. Sears is known for its care in ensuring that home products (appliances, linens, etc). are color–compatible with each other. A refrigerator purchased in Sears "almond" is very likely to be an acceptable match to Sears "almond" dish towels or pots, and both are likely to be compatible with other nationally distributed products, like plastic laminates, with the same color name.[21]

Maintaining a laboratory for color and light problems isn't realistic or necessary for graphic, textile, fashion, or interior designers, architects, small-scale manufacturers, or product designers. General Electric suggests that any pair of objects reaching acceptable match under both fluorescent and incandescent lamps will be acceptable under almost all conditions.[22] This practical advice covers almost all color-compatibility situations, as long as the real limitations of color matching between two different materials are understood.

A sample submitted for color matching is a *standard*. There are times when the match to a standard must be stable under all light conditions. In order for this to happen, the new goods must be made of the same substrate (base material) and the same colorant used as in the original standard. A match that is perfect under any light conditions is possible only when the original standard and the new product are identical.

Manufacturers who control the complete production and color process can offer near-perfect matches to a standard. Edward Fields, Inc., is a manufacturer of high-quality wool carpeting that provides this service. Raw wool is tested before weaving for oil content, which affects readiness to accept dye. Each new batch of dyes is lab-tested for chemical consistency. Final samples are dyed and compared to the original standard. The finished product can be produced with near-perfect match because the substrates and dyes are the same. But throughout the process and at its conclusion the match is judged not by laboratory testing but by the dyer, the manufacturer, and the client: *by human eyes alone*.

[21] *See* Chapter 8, "The Business of Color."

[22] General Electric Lighting Application Bulletin #205–41311.

Luminosity

Luminosity is a word that appears often in color study. Its real meaning is the attribute of emitting light without heat. A luminous object is light-reflective, but it does not emit heat. The word luminous is used often to describe very light-reflecting colors. Watercolor, for example, is described as a luminous medium because light reaches through the colorant to the white of the underlying paper and creates the effect of a sparkling, brilliant surface. Watercolor on black paper is not luminous, because no light reflects back from the underlying black paper.

Indirect Light, Indirect Color

Indirect light occurs when light from a light source reaches a broad surface that re-reflects it onto a second surface or object. In order for this to happen, the light source, the reflective surface, and the target—an area, surface, or object—must be at angles to one another. Moonlight is a familiar form of indirect light. The moon is *luminous*: it reflects light but does not emit its own energy. Its surface reflects the light of the sun to the earth.

Each time light travels, some of it is lost through scattering. Moonlight is weaker than sunlight because much of the sun's light has been scattered and lost, first on its way from the sun to the moon, then again from the moon to the earth. Still, the moon is a good reflector; moonlight can be strong enough to read by. Indirect lighting works in the same way as moonlight does. General light reaching a white reflective surface re-reflects onto a target surface or object. The light lost in travel causes the target surface to appear slightly darker than it might under a direct light, but no other change in its apparent color takes place.

Indirect *color* is a variant of indirect light. It, too, relies on the angle of placement of a light source, a reflective surface, and a target area. Indirect color occurs when general light reaches a highly reflective *color* on a broad plane. A good deal of colored light (and some of the general light) reflects onto the target surface, changing its apparent color.

Imagine sunlight reaching a wall that is covered with a highly reflective green paint. The green surface absorbs all wavelengths except the green, which is scattered or reflected onto a nearby chicken. If the chicken is white, its surface will reflect the green wavelength reaching it and the chicken will appear to be green. If the chicken has a different coloring, the result will depend on that colorant's interaction with the green light reaching it. If the chicken has red feathers, the green wavelength reaching it will be absorbed and the chicken will appear dark, dull, and nearly black.

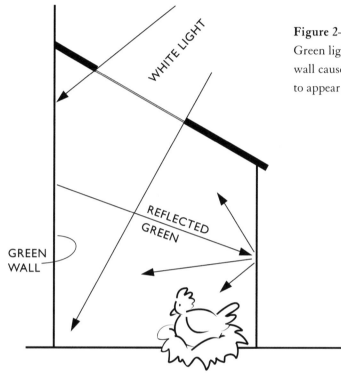

Figure 2–10 *Indirect Color.*
Green light reflected from a
wall causes the (white) chicken
to appear green.

One way to describe the phenomenon of color reflected from one surface to another is
plane reflection. The design applications most vulnerable to this are architecture and
interior design, where planes of color on walls, floors, and ceilings interact with direc-
tional light sources to create potential conditions of light and color reflection. Although
the strength of indirect color is diluted by scattered general light from the original source,
plane reflection can cause substantial—and unexpected—distortions in architectural
and interior design color programs.

Modifying Light: Filters

Filters are materials that transmit (pass through) some wavelengths of light and absorb others.
A red filter placed between a light source and an object allows the red wavelengths to
pass through and absorbs the other wavelengths. An object with a red colorant, seen
through the filter, appears red. An object with a white colorant also appears red because
a white surface reflects any wavelength reaching it. If the object reflects a color other

than white or red, however, it will appear black (or near-black). The red filter transmits only the red wavelength. No other color reaches the object, so none can be reflected back.

Filters are like Aladdin's genie. They have plenty of power, but they only follow directions, so the directions need to be good ones. *The New York Times* once published the story of a restaurateur who wanted to create a romantic atmosphere by bathing his establishment in warm, rose-red light. Instead of using lamps with a strong red wavelength (which would have provided a rosy white light, but allowed all colors to be seen), he installed red theatrical gels (filters), which blocked all the wavelengths except red. The gels were extremely effective: vegetables and salads arrived at the tables black.

Figure 2–11 *Filters.* A filter absorbs some wavelengths of light and transmits others. When a filter is placed between a light source and an object, only the transmitted wavelengths reach the object.

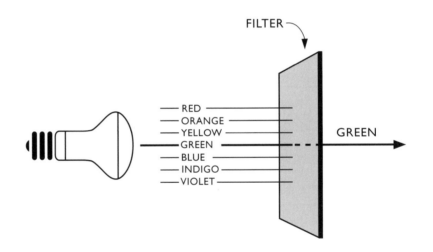

REFERENCES

Billmeyer, Fred W., and Max Salzman. *Principles of Color Technology*. New York: Interscience Publishers (division of John Wiley & Sons, Inc.), 1966.

De Grandis, Luigina. 1984. Translated by John Gilbert. *Theory and Use of Color*. New York: Harry N. Abrams Inc., Publishers, 1984.

Goldstein, E. Bruce. *Sensation and Perception*. Belmont, CA: Wadsworth Publishing Company, 1984.

Hope, Augustine and Margaret Walch. *The Color Compendium*. New York: Van
 Nostrand Reinhold Company, 1990.

http:bway.net/-jscruggs/add.html

Light and Color. General Electric Publication TP–119, 1978.

Lighting Application Bulletin. General Electric Publication #205–41311, undated.

Loveless, Richard, editor. *The Computer Revolution and the Arts*. Tampa: University of
 South Florida Press, 1986.

Mahnke, Frank H. and Rudolf H. Mahnke. *Color in Man Made Environments*. New
 York: VNR, 1982.

Sappi Warren. *The Warren Standard Volume Three No. Two*. SD Warren Company, 225
 Franklin Street Boston, MA 02110 #96–5626 ©1996.

Sloane, Patricia. *The Visual Nature of Color*. New York: Design Press, 1989.

Solso, Robert L. *Cognition and the Visual Arts*. Cambridge, MA: The MIT Press,1994.

The Color Theories of Goethe and Newton in the Light of Modern Physics. Lecture held in
 Budapest on April 28, 1941, at the Hungarian Club of Spiritual Cooperation. Published
 in German in May, 1941 in the periodical Geist der Zeit. English translation courtesy
 of Dr. Ivan Bodis-Wollner, Rockefeller University, New York, 1985.

Vince, John. *The Language of Computer Graphics*. London: Architecture Design and
 Technology Press, 1990.

The Human Element

3

The Sensation of Color / Visual Acuity for Color / Threshold /
Intervals / The Perception of Color / Physiology: Responding to
Light / Healing and Color / Synaesthesia / Responding to Light:
The Mind / Color as Symbolic Meaning / Naming Colors

> *Color responses are more tied to man's emotions than to his intellect. In general,
> people do not respond to color with their minds.*[23]
> — Deborah Sharpe

Of all the senses that connect us to the world—vision, hearing, taste, smell, and touch—
vision is the most important. More than 80% of our sensory experiences are visual. We
are drawn to light, and to color.

The instrument used in solving color problems in the design industries is the normal,
unaided, human eye.[24] For artists and designers, dyers and house painters, printers and
carpet sellers, even when aided by commercial color charts or professional color sample-
systems, final decisions about color are made by human eyes alone.

The Sensation of Color

The experience of color begins with a *sensation*. A sensation is an actual, physical event.
It is the body's response to a *stimulus,* something that is encountered from the outside
world. Light, or visible energy, is the stimulus for the sensation of sight. A stimulus is
measurable. The color and quantity of light emitted by a light source can be measured.

Sensations are also measurable. An individual's ability to sense light is measured as
visual acuity, or sharpness of vision. Visual acuity is the ability to sense patterns of light
and dark and to resolve detail. It is a measure of the weakest light stimulus that an
individual can detect. The ability to see differences in dark and light is not visual acuity
for color. Someone who can discriminate very small differences between a dark gray
and a slightly lighter one may not be able to detect a difference between two similar
reds, one of which is slightly more orange or more blue than the other.[25]

Visual Acuity for Color

Visual acuity for *color* is the ability to detect different wavelengths (colors) of light. The
individual colors of light can be measured using scientific instruments, but human beings

[23] Sharpe, Deborah. 1974. *The Psychology of Color and Design*. Chicago: Nelson Hall Company. Page X.

[24] Clear corrective lenses (untinted eyeglasses or contact lenses) that magnify or correct image distortion are part of normal,
unaided, color vision. "Color-blindness" is a catchall term for a number of forms of color-deficit vision. A "color-blind" indi-
vidual may see only dark and light, with no colors at all, or may be deficient in only one or two hues.

[25] Color vision is a complicated and still poorly understood area of physiology. There are two major theories of how color is
seen. The trichromatic theory hypothesizes that color vision results from the stimulation of cones in the eye with different
sensitivities to light (Young-Von Helmholtz). The opponent-process theory (Hering) theorizes the build-up and breakdown
of a chemical in the retina in response to light.

do not sense the spectrum as separate colors. Instead, the spectrum of visible light is sensed as an unbroken band of colors, with each color blending into the next, like a rainbow.

Color vision enables a viewer to discriminate small differences between hues in this continuous band, like the difference between a red and a red-orange, or a blue and a blue-violet. An average human eye can discriminate about 150 steps, or different colors, of *light*. It makes no difference whether the colors are seen as light directly from a light source or as light reflected from a surface. This number doesn't include darker, lighter, or duller variations of each color. The multiples of the 150 visible colors and their variations mean that a person with normal color vision can distinguish millions of different colors.

Threshold

The *threshold* of vision is the point at which an individual can no longer detect a difference between two close samples. The threshold of *color* vision is the point at a difference between two similar *hues* can no longer be discriminated. Individuals with normal color vision vary in the threshold of color acuity just as much as they do in their ability to see detail. Each person's vision is modified by factors like individual physiology and health. Age also plays a part in color vision. Infants are believed to perceive dark/light images before they can see colors, and older people experience a progressive loss of color acuity in the blue range. Blues, greens, and violets become more difficult to discriminate with age.

Figure 3–1 *Close Intervals.* Intervals this close are difficult for some people to see. Others with greater visual acuity can see the differences between the squares without difficulty.

Intervals

One way to characterize differences between color samples is in *intervals*. An interval is a step of change between visual sensations. An individual's threshold establishes the *single interval:* the point at which a detectable middle step can no longer be inserted between two close colors. The single interval is specific to each individual. Single intervals are important only in determining a person's threshold.

Most design situations involving intervals involve *three* elements: the "parents" (samples on either side) and the "descendant," a visual step between the two parents. There are three qualities of color:

> *Hue*: the name of the color: red, orange, yellow, green, blue, or violet.

> *Value*: the relative lightness or darkness of a sample.

> *Saturation* or *chroma*: the hue-intensity or brilliance of a sample, its dullness or vividness.

Intervals are *visual* mixes. *They are judged by eye alone.* Members within a group will rarely arrive at complete agreement as to the exact midpoint between two samples. The disagreement is about nuance, not about enormous differences, and can be attributed to individual differences in perception. A perfect interval, like perfect weather, is an opinion that includes a generous portion of fact.

Intervals can be set up between colors having only hue difference, like red and blue; only value difference, like black and white; or only difference in saturation, like brilliant blue and gray-blue. Intervals may also be established between color samples that contrast in two or all qualities. A pale pink and a dark gray-blue have hue, value, and saturation contrast, but a series of intervals can still be set up between them.

Even intervals occur when the middle step is visually equidistant between the two parents. A representative set of even intervals is black on one side, white on the other, and middle gray between them. Another is red on one side, yellow on the other, and orange between them. The important thing about even intervals is that the midpoint be just that, no closer to one parent than to the other.

Figure 3–2 *Even and Uneven Intervals.* The upper set of squares are even intervals—the center is a middle step between the two "parents." In the lower squares, the center is more like one parent than the other. The intervals are uneven.

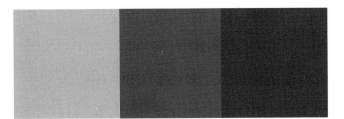

Intervals aren't limited to the three steps of parent-descendant color mixtures. In a *series* of even intervals, each step is the visual midpoint of the sample on either side of it. Even intervals play such a major role in color study and color harmony that the word "interval" alone is sometimes used to mean a visually equidistant step.

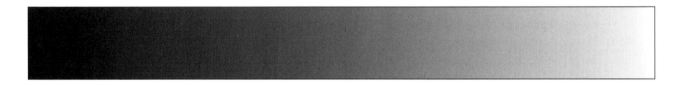

Figure 3–3 *Intervals in Series.* In a series of even intervals of value, each step is the midpoint between the two on either side of it.

Intervals can be made to be deliberately uneven, or more like one parent than the other. Tilting a middle color closer to one parent color than the other is a technique used by artists and illustrators to create special effects or illusions.

A *gradient* is a series of progressive intervals that are so close that individual steps cannot be distinguished. It is a seamless transition between color differences, whether the difference is from light to dark, or from one hue to another, or from a brilliant color to a dull one. A "wash" of colors, like shading from one color to another, is a gradient. The intervals of a gradient are below the threshold of normal vision.

Figure 3–4 *Gradients.* A gradient is a progression of intervals, but the steps of change are smaller than the human eye can distinguish. A gradient is a movement from one color sample to another. It can be a change in hue, value, saturation, or all qualities.

The Perception of Color

A sensation alone (whether it is a sight, sound, taste, smell, or touch) is an incomplete event. The occurrence of a sensation is followed immediately by *perception*. Perception is the critical connection between human beings and their environment. It is the understanding and awareness of a sensory event. Perception both *decides* what has been sensed and *identifies* the sensation. It also acts as a filter, separating useful and important information from competing stimuli in the environment.

When the brain receives a light stimulus it first interprets form as distinct from background. To do this, it senses patterns of light and dark. *Figure-ground separation*, or *pattern recognition*, is the first cognitive step in the process of perception. It identifies situations by forms and by their arrangement.

Color plays an important, but secondary, role in recognition. A red file folder (unpaid bills) and a blue file folder (paid bills) appear at first to be identified by color. But both red and blue folders are identified first as file folders, and only secondly by the assigned color meanings. The initial recognition is of form: this is a file folder, not a notepad, not a CD, not a book.

All recognition is based on learned information from every possible source: individual experience, social and cultural traditions, environmental surroundings, formal teaching. The ability to recognize sensations develops with astonishing rapidity, beginning almost at birth. By adulthood human beings have acquired and stored an immense "library" of known sensations. New ones, unless they are accompanied by additional information, are identified by referring to this "library." Something new is recognized, rightly or wrongly, because it is associated with some familiar thing that has similar characteristics.

Creating order out of random stimuli is a fundamental function of human intelligence. Things are categorized in order to control and understand the flow of information: large to small, A to Z, ascending numbers, dates, or sizes. More orderly information is easier for the brain to process; chaotic stimuli are more difficult for the brain to process. Even intervals are orderly. They are satisfying because they are easy for the eye and brain to process. A series of even intervals of any kind—hue, value, or saturation—is easier to "read" than a random grouping.

Most perceptions occur unconsciously and at such high speed that they seem simultaneous with sensation (Rodemann 1999, page 155), but what we think of as the "sensory" experience of color is really a fusion of sensation and perception. *Unlike a sensation, a perception cannot be measured. It can only be described*.

Physiology studies the body and its functioning. It is a measurable science that can quantify the body's physical responses to a stimulus of color. Psychology studies behavior; or how organisms react when they are stimulated in different ways. Psychology can describe—but cannot precisely measure—the ways in which human beings recognize, interpret, and respond to the stimulus of color. Psychology deals with perception.

Physiology: Responding to Light

The eye is an organ that is adapted to detect light. Light enters the eye through the pupil and falls on the retina, the inside back of the eye. The retina is made up of two kinds of light-sensitive receptor cells, *rods* and *cones*. Both rods and cones connect to the optic nerve, which transmits the sensory message from the eye to the brain.

Rods and cones respond selectively to available light. Cones dominate vision when a great deal of light is present. Cones are responsible for color vision and for the ability to see detail. Objects appear more colorful and fine detail, like small print, is clearer when cones are dominant. Rods dominate vision in low light. Rods are responsible for peripheral (surrounding, less focused) vision. Colors appear muted, and fine detail is more difficult to see when rods dominate.

The *fovea* is a tiny area at the back of the eye that contains only cones. It is the center of the visual field.[26] The fovea is the most sensitive area of the retina. It detects patterns of light and dark and color with the greatest clarity. Images and colors are seen less clearly when the light stimulus moves away from the fovea.

Figure 3–5 *The Human Eye*

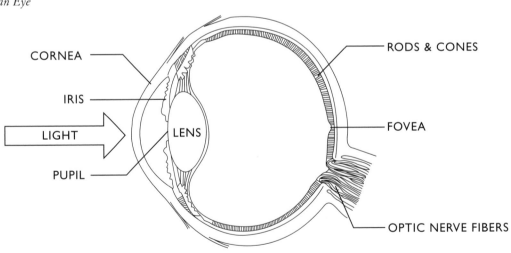

THE HUMAN EYE

[26] The visual field is the area that is seen by the two eyes of a viewer standing in one position. An average person's visual field is 90 degrees from center left or right (180 degrees horizontally) and 65 degrees up or down (130 degrees vertically).

Both rods and cones are always at work. It is almost as if there are two separate systems, one for day and one for night. *Adaptation* is the involuntary response of the eye to the quantity of available light.[27] The retina moves back and forth (adapts) quickly between rod and cone dominance as the amount of available light increases or decreases. Objects appear more colorful at higher lighting levels, when cones dominate. Color perception lessens in dim light when rods dominate; perception in low light is in shades of gray. A garden that is colorful by day loses its apparent color gradually toward evening, but the contrast of dark foliage and light flowers remains—a different, but equally pleasing, image. Adaptation is an innate response of the eye. "Cones for color, rods for gray tones" is the same for sunlight or lamplight, fluorescent, incandescent, or any other kind of light. The sly old metaphor is literally true: all cats really *are* gray in the dark.

Lateral inhibition is an aspect of vision that increases the eye's ability to distinguish edges. When a pattern of light and dark contrast reaches the retina, the cells that receive the light part of the image inhibit the ability of the ones next to them to detect light. As a result, areas next to bright spots appear darker. The greater the quantity of light, the more lateral inhibition takes place—light areas appear lighter and dark areas darker. Lateral inhibition makes it easier to see images that already have value contrast, but it does not help in seeing images that have little contrast of dark and light.

The sensation of light is received in two areas of the brain: the cerebral cortex and the hypothalamus, or midbrain. The cerebral cortex is the center of *cognitive activity*. It receives information and processes it: recognizing, identifying, and structuring a response to each stimulus.

The midbrain controls the internal environment of the human body. Sensations of light transmitted to the midbrain act as a *biological stimulus* to the central nervous system. The midbrain contains the center for regulation of blood pressure and body temperature. It also stimulates glands that control the production and release of hormones. When the brain is stimulated by a thought, mental image, or outside stimulus (like light), the midbrain triggers the release of hormones. This response means that a color stimulus has an effect on the strongest human needs and emotions—stress, hunger, thirst, and sex.

The immediate biologic response of the body to a stimulus is *phasic arousal*. Phasic arousal is abrupt and lasts very briefly, like the surge of adrenalin that is experienced in a suddenly frightening situation. *Tonic arousal* is the body's response over a prolonged period. The body has a "norm" for tonic arousal, and the brain continually directs the adjustment of

[27] Adaptation should not be confused with *accommodation*, which is the movement of the lens of eye as it changes focus from near to far objects.

hormone levels to keep it at that norm. Phasic arousal is needed as a stimulus. Stimulation by a strong color causes an immediate reaction that can be physiologically measured, but *the duration of the effect is not continuous*.

Sunlight, which contains all colors, is essential to human life. The human body is genetically adapted to function at a "normal" level in response to the sun's pattern of energy emission. Changing the strength of a color stimulus causes a change in the body. Exposure to a an elevated level of red wavelength stimulates hormone production and raises blood pressure; exposure to am elevated level of blue wavelength has been shown to lower blood pressure and depress hormonal secretions.

Because exposure to color changes the body's hormonal balance, it also causes changes in behavior. A designer can direct the type and degree of color stimulation, and by extension, influence behavior. Colors can be chosen to stimulate, depress, or otherwise alter mood. In environmental design, overstimulation and understimulation have equally negative effects: human beings respond best to environments that have color, but not overwhelmingly powerful color. A graphic designer may choose a high level of stimulation to draw attention. Restaurant designers use red to stimulate the appetite. The muted colors of funeral homes are meant to minimize emotional response. An extreme example of color used to modify behavior occurs with a color known as Baker-Miller pink (a bubble-gum pink). Exposure to Baker-Miller pink has been shown to reduce aggressive behavior.[28] Its effects begin after a short period of exposure and last about for about half an hour—a perfect illustration of the body's arousal pattern.

Colors can also be experienced without a stimulus of light. The brain alone, without a light stimulus, allows us to dream in color, or to imagine color with closed eyes. A headache or a blow to the head can trigger images of blue stars. We can also see color in the mind's eye.

Healing and Color

The eye is not the only organ that responds to light. Light is also absorbed through the skin. The use of colored light to act on the body through the skin is a routine medical practice. The treatment of jaundiced infants with light is a standard (and effective) therapy, as is the treatment of psoriasis, a skin disease, by exposure to sunlight.

The use of color to heal has a long history. Ancient color therapies included (among

[28] The color must be applied to all surfaces except the floor in a room of limited size in order to have an effect.

other treatments) the application of colored *substances* to the skin. Some were helpful, but not because of their color. They were effective because the applied substance had medicinal properties. A purple dye extracted from shellfish was used by the ancient Greeks as a treatment for ulcers. The dye had a high calcium content, and the calcium absorbed through the skin had a palliative effect.

Color therapy remains an active discipline. Most contemporary color therapists ascribe healing properties to different wavelengths, rather than to colored substances. Certain colors of light are thought to have affinities to different parts of the body. The medical establishment is skeptical of these claims, and the practice of medicine by color therapists is illegal in the United States.

Synaesthesia

Synaesthesia is a long-recognized but largely unexplained phenomenon in which one sense responds to the stimulation of another. There are reports of blind persons (and others) who are able to determine the colors of objects through touch.[29] A woman reports a humming sound when she enters a certain red room; the sound stops as soon as she leaves the room. A man reports a strong taste of lemon when he listens to a particular piece of music. Research indicates that the sensory pathways to the brain are connected to each other in ways that can be demonstrated but are not yet understood. The idea that undiscovered connections exist between the senses seems less surprising when we remember what an ordinary thing it is to experience "chills"—ordinarily a reaction of the skin to change in temperature—from an emotional, musical, or visual experience.

Responding to Light: The Mind

Visual acuity for color, hormonal responses to color, adaptation, and synaesthesia are physiological and involuntary responses of the body to a stimulus of light. The perception of color is also influenced unconsciously by things that have been *learned*. Psychological responses to color are involuntary responses that take place in a different way. They are *cognitive*, or "knowing" responses. The brain (specifically, the cerebral cortex) recognizes and selects a response to the color stimulus.

One psychological influence on color perception is a kind of expectation called *memory color*. Memory color means that the viewer makes an unconscious assumption about the

[29] A possible explanation for this may be that certain individuals are able to detect wavelengths and the differences between them through touch. Someone with a deficit in one or more of the senses tends to develop greater acuity in the remaining ones. Once told that a certain tactile sensation means "red," a person with that sensitivity would be able repeatedly to distinguish the "red" sensation from others.

color of something, the "orange" of an orange, for example, or the "red" of an apple. A viewer influenced by memory color does not report the actual color experienced. Instead, what is reported (or even illustrated) is a preconceived idea. A ripening apple may be more green than red, but it will be described as red. At times the sea can be nearly maroon; even at these times an amateur painter will "see"—and paint it—blue.

Memory color affects the observation of an object of familiar coloration. *Color constancy* is a second and equally powerful form of expectation. Color constancy means that the eye and brain together adapt to all general light sources as if they were the same. Familiar objects and locations retain their identity under different conditions. The same colors seen in a daylit room and at night under incandescent light may be dramatically different, but the viewer is unaware of those differences. Because colors have been experienced in one way, both individually and in relation to each other, the "stored" image overrides what is actually seen.

A second kind of color constancy occurs when similar colors are perceived as being identical. In an all-white kitchen, the white of the refrigerator, the counters, the floor, the cabinets, and the paint may all be different, but the immediate cumulative effect is that they are the same. The various surfaces are categorized mentally as "white," and the concept of "whiteness" prevails over what is actually seen.

Memory color and color constancy screen out important color differences from ones that do not matter. It can be appropriate to look for fractional differences between colors (in a design situation, for example), but a constant concern with small color differences would be exhausting if it applied to everything in daily life. Because memory color and color constancy simplify and edit what is seen, they play a large and proper role in the visual comfort of living with color.

Color as Symbolic Meaning

In *Color, Environment, and Human Response*, Frank H. Mahnke describes the experience of color as a pyramid with six levels of response (Mahnke 1982, page 11):

personal relationship
influence of fashions, styles and trends
cultural influences and mannerisms
conscious symbolism-association
collective unconscious
biological reactions to a color stimulus

The lowest two levels of Mahnke's pyramid are innate, unlearned responses to color. Sensation is the physiological response to a stimulus of light, and the "collective unconscious" refers to responses that are universal and cross-cultural, like the association of the color red with blood. The remaining levels of response are learned. Colors are understood to have meaning: to symbolize or be associated with non-color ideas.

Symbolic colors are understood as direct representations of something else. They have an *assigned* meaning. National flags are the classic example; no further identification is needed when someone refers to "the red, white, and blue." The federally mandated Occupational Safety and Health Administration (OSHA) colors are used nationwide to communicate safety information: red for fire-fighting equipment, for example, or violet for radiation hazard.[30] School buses (and New York City taxicabs) are yellow. It is easier to find a police car in a hurry when it is a "panda"—black and white.

Other associations of colors and ideas are more specifically cultural. They have one meaning in one social context, a different meaning in another. The white that symbolizes purity in Western culture is the color of mourning in India. Cultural associations of colors with ideas are so ingrained that they lie in subconscious memory. Nowhere is this better illustrated than in language. Colors that had at one time formal symbolic meanings may lose the original symbolism over time, but the association of color and idea persist. Which came first—the Western European association of yellow with cowardice and treachery, or the Medieval convention of painting Judas in a yellow robe?

Associative or impressional colors suggest ideas without being specifically cultural or formally symbolic. Green is associated with the environment. Blue is associated with sky and water. Red is associated with passion (of all kinds): "There are reds that are triumphal and there are reds which assassinate"(Varley, 1980, page 132).[31]

Mahnke's "personal relationship" of color experience also enters into unconscious memory. A long-forgotten association will create a preference for (or dislike of) a color. Aunt

[30] United States Congress Occupational Safety and Health Act of 1971.

[31] Quoting Leon Bakst.

Agatha made you eat broccoli in her pink kitchen; you hate broccoli *and* pink. Personal experience also determines each person's concept of colors: if ten students are told to imagine a perfect red apple, and ten apples appear magically in the air, each apple is a different red. Each person imagines "perfect red" in a slightly different way.

Naming Colors

When the brain has received sensory information, it identifies it—by name. Just as no one can know precisely what another person sees, no one can experience anyone else's idea about a color name. If a teacher presents a class with a *real* red apple and asks students to name the red, responses will be as prompt as they are varied; bright red, apple red, pure red, true red, and so on. Individuals are capable of seeing hundreds of possible reds and unconsciously expect that each is a fixed color with its own name.

External evidence tells us that most people see the same thing when they see "red." We accept that something is red not by scientific measurement of wavelengths but by unspoken agreement, common language, and common experience. Everyone identifies green leaves as green, not as orange. The disagreements that arise about the names of colors are about *nuances* of color, not about broad categories. Something that is red is more red than it is anything else. It may be a bluer red or a yellower red, but no one would ever call it blue or yellow.

Color study requires only six names for colors: *red, orange, yellow, green, blue*, and *violet*. Each name represents a *family* of closely related colors. Restricting the names for colors to six words enables the viewer to focus on the visual experience. Design and marketing professionals use (and need to use) romantic names for colors, like Venetian Red, Bermuda Blue, or Aztec Gold because the images they evoke play a major role in marketing. Both ways of naming colors are important in a designer's education as long as the critical difference between the two is recognized: the six hues of color study deal with eye training, color recognition, and color use; the many color names of industry are about product image and sales.

REFERENCES

Arnheim, Rudolf. *Visual Thinking*. Berkeley and Los Angeles: University of California Press, 1969.

Birren, Faber. *Color Perception in Art*. New York: Van Nostrand Reinhold, 1976.

Cotton, Bob and Richard Oliver. *The Cyberspace Lexicon*. London: Phaidon, 1994.

Goldstein, E. Bruce. *Sensation and Perception*. Belmont, CA: Wadsworth Publishing Company, 1984.

Hope, Augustine and Margaret Walch. *The Color Compendium*. New York: Van Nostrand Reinhold Company, 1990.

Mahnke, Frank H. and Rudolf H. Mahnke. *Color in Man Made Environments*. New York: VNR, 1982.

Rodemann, Patricia A. *Patterns in Interior Environments: Perception, Psychology and Practice*. New York. John Wiley & Sons, Inc., 1999.

Sharpe, Deborah. *The Psychology of Color and Design*. Totowa, NJ: Littlefield, Adams and Company, 1975.

Sloane, Patricia. *The Visual Nature of Color*. New York: Design Press, 1989.

Solso, Robert L. *Cognition and the Visual Arts*. Cambridge, MA: The MIT Press, 1994.

The Random House Dictionary of the English Language. Jess Stein, Editor-in-chief. New York: Random House, Inc., 1967.

Varley, Helen, editor. *COLOR*. New York: The Viking Press Distributors. Los Angeles: The Knapp Press, by Marshall Editions Limited, 1980.

Vince, John. *The Language of Computer Graphics*. London: Architecture Design and Technology Press, 1990.

Color Description

Hue / The Artists' Spectrum / Primary and Secondary Colors / Saturated Color / Other Spectrums, Other Primaries / Chromatic Scales / Cool and Warm Colors / Analogous Colors / Complementary Colors / Equilibrium / Simultaneous Contrast / Afterimage and Contrast Reversal / Complementary Contrast / Tertiary Colors: Muted Hues and Brown / Black, White, Gray / Value / Value and Image / Transposing Image /Pure Hues and Value / Tints and Shades / Tone / Monochromatic Value Scales / Comparing Value in Different Hues / Saturation / Saturation: Diluting Pure Hues with Gray / Saturation: Diluting Pure Hues with the Complement

Trying to communicate ideas about colors with words can be one of the most frustrating experiences imaginable. No two individuals see or think of colors in exactly the same way. One person's peach is always another person's melon. Design professionals use a color vocabulary that enables them to discuss color ideas with reasonable precision. Professionals describe colors and differences between them in terms of their *qualities*. Every color has three separate and distinct qualities:

>*Hue*: the name of the color: red, orange, yellow, green, blue, or violet

>*Value*: the relative lightness or darkness of a sample

>*Saturation* or *chroma*: the hue-intensity or brilliance of a sample, its dullness or vividness

The words hue, value, and saturation describe aspects of some tangible or intangible *thing*: a car, a dress, a cow, a wavelength of light, or paint on paper. The *thing* is implied when we say "yellow" or "blue" or "red." There is red light and red paint and red onion pie, but there is no object "red." The same is true for "dark" or (in the descriptive sense) "light," and for "dull" or "vivid." Each word describes a quality of some thing, whether that thing is named or just implied.

The qualities of hue, value, and saturation coexist in every color we see. They expand the description of any object. "Where is my dark red shirt?" gives more information about the color of my lost shirt than "where is my shirt?"

Hue, value, and saturation describe colors, but these words are used most effectively as *comparative* terms. Colors may be very similar or very different, but the differences between them can always be described in terms of hue, value, or saturation: "Honey, let's buy that light (value) grayish-blue (saturation/hue) car. I don't like the dark (value) green (hue) one."

Hue

Hue means the *name* of the color we see. The average person can distinguish about 150 colors of light, and every one can be described using one or two of only six words. The only names ever needed to describe hue are:

Red Orange Yellow Green Blue Violet

The word "color" is used as a synonym for hue. The color of something *includes* its hue, but it includes other qualities as well. Chroma, another synonym for hue, is part of some familiar color words:

Chromatic:	Having hue
Achromatic:	Without discernible hue
Polychrome:	Having many hues
Monochromatic:	Having one hue only[32]

A color is called by the name of its most obvious or dominant hue. Every color belongs to a family of closely related hues. No sample is the exact, "perfect" named hue.[33] A color "contains" more that one hue, but the hues are present in different proportions, and one is dominant. A sample may seem to be "pure yellow" until it is placed next to another "pure yellow" sample. Suddenly, one yellow is seen to contain a bit of green; the other, a fraction of orange. Both are *called* yellow because yellow is the predominant hue in each. Using the word *contains* is a nearly foolproof way to evaluate a color sample. "This yellow contains some orange" is perfectly descriptive. It identifies the principal hue and a second one that modifies it.

[32] But not necessarily only one value or saturation. See Value and Saturation, below.

[33] Specific wavelengths of light can be considered "perfect" or "pure" hues when they are measured using scientific instruments.

The Artists' Spectrum

The *artists' spectrum* is a circle that displays all of the visible hues. (*See* Figure C–1 in color insert.) The artists' spectrum is also called the *color wheel or color circle*.[34] There are too many possible hues in the range of human vision to include all of them easily in one circle, so the spectrum is a sort of visual outline, or synopsis. The basic artists' spectrum includes the six named colors in even intervals of hue: red, orange, yellow, green, blue, and violet. An expanded spectrum has twelve intervals of hue, but no new color names are introduced to illustrate it. The expanded artists' spectrum includes:

Red, *Red-orange*, Orange, *Yellow-orange*, Yellow, *Yellow-green*,
Green, *Blue-green*, Blue, *Blue-violet*, Violet, *Red-violet*.

Figure 4–1 *The Artists' Spectrum*

The artists' spectrum is limited to six or twelve hues only because this is a concise, easily-illustrated figure. It can be expanded to any number of hue intervals as long as the additional hues are inserted evenly in all hue ranges. There can be six, twelve, twenty-four,

[34] The *color wheel* is a term also used to mean a circle of color devised by scientist James Maxwell to demonstrate both a psychophysical response called persistence of vision and the additive nature of colored light. (Hope 1990, page 201).

forty-eight, ninety-six, or more hues (but not thirty-seven or fifty-one). The only limits to the number of places on a color circle are the visual acuity of the viewer and the practical problems of illustrating it.

The spectrum of visible light (additive color) is linear, moving from short wavelengths of light (violet) to long ones (red), and the order of colors is fixed. (*See* Figure C–2 in color insert.) The artists' spectrum is also fixed in its rotation, or order, of colors, but it has six colors, not seven, and it is circular and continuous. Violet forms the bridge between red and blue. (*See* Figure C–1 in color insert.)

Color circles can be illustrated correctly in many different ways. If the medium used is a display of colored light on a monitor screen, the colors will be sharp and clear. More opaque media like gouache or acrylic paint will illustrate colors as "deeper." As long as the hues are in sequence and the intervals well-spaced, color circles can vary a great deal in appearance from each other and be equally true.

Primary and Secondary Colors

Red, yellow, and blue are the primary colors of the artists' spectrum. They are the simplest hues. They cannot be broken down visually into other colors or reduced into component parts. The primary colors are also the most different from each other, because they have no elements in common. All other colors on the artists' spectrum are mixed visually from the primaries red, yellow, and blue. [35]

A secondary color is an even interval between two primary parents. *Green, orange, and violet* are the secondary colors of the artists' spectrum. Each is the visual midpoint between two primary colors. Mixing two primary colors to the midpoint is done *by eye*:

> Green is the middle mix of blue and yellow.
> Orange is the middle mix of red and yellow.
> Violet is the middle mix of blue and red.

The secondary colors are less contrasting in hue than the primary colors. Each secondary color has one primary color in common with the each of the others. Orange and violet each contain red, orange and green each contain yellow, and green and violet each contain blue.

[35] *See* Chapter 7, "Tools of the Trade."

The primary and secondary colors make up the basic spectrum. The expanded spectrum includes the intermediate colors that lie between the primaries and secondaries as well (see above). These colors have no special category, although many times they are referred to *incorrectly* as tertiary colors.[36] Like the secondary colors, they are the visual midpoints of the colors on either side of them. Yellow-green, for example, is the interval between the primary yellow and the secondary green.

Saturated Color

A *saturated color* is a hue in its strongest possible manifestation. The reddest red imaginable, or the bluest blue, are saturated colors. Saturated colors are also called *pure colors* or *full colors*. Saturated colors are said to be at maximum chroma. Saturated or pure colors are also defined by what they do *not* contain. A saturated hue contains one or two primaries in any mix or proportion, but never includes the third primary. A saturated hue does not contain black, white, or gray.

Saturated colors are not limited to the six or twelve named hues of the artists' spectrum. Any hue, inserted at any point between saturated hues on the color circle, is also a saturated hue. Imagine the full range of saturated colors as a circle with each color blending into the next, like a rainbow. Any point on that circle is a saturated color. Red-red-orange or blue-blue-green are saturated colors as certainly as red, or orange, or blue, or green. As long as a color contains only one or two primaries and is undiluted by black, white, or grey, it is a saturated color. The only limit to the number of saturated colors is the limit of human color vision.

Other Spectrums, Other Primaries

The artists' spectrum illustrates one color-order system. It's familiar, visually logical, easy to represent as a two-dimensional figure, and it allows for theoretically unlimited expansion.

Scientific and nonscientific disciplines use other spectrums to illustrate alternative color-order systems. Choosing one spectrum instead of another is exactly that: a choice. No spectrum is inherently more correct than another. The systems may vary in the names of colors, the number of colors illustrated (from three or four to infinite) and in the assignment of what might be called "prime points" on the wheel. The color theorist

[36] Tertiary colors contain all three primaries (*See* Tertiary Colors, below).

Wilhelm Ostwald predicated an eight-hue spectrum that contained sea-green (blue-green) and leaf-green (yellow-green). Psychologists construct a four-hue spectrum with red, green, yellow, and blue as the primaries.

These different color circles may appear at first to conflict, but they are all variants of the same color-order idea. All recognize the same sequence of colors: red, orange, yellow, green, blue, violet. Hue intervals may be added or subtracted, but no spectrum moves directly from red to green, or from orange to blue. Arguments made for the names or locations of primaries and secondaries are intellectual exercises. All color circles include the visible hues in some way, and all follow the same color order.

Infants, before they can see hue, are able to detect differences in dark and light. This first experience of vision persists through life. The ability to see light-dark contrast (figure-ground perception) is basic to human perception. The contrast between light and dark is *value*. Light colors are high in value; dark colors are low in value. More individual steps can be discriminated between yellow-to-red and yellow-to-blue than can be seen between red-to-blue because there is a greater difference in *value* between yellow and the other two primaries than there is between red and blue. Yellow is much lighter than blue or red, so many steps can be set up between yellow and red or between yellow and blue. Blue and red are closer in value; so a series of perceptible step between them is shorter.[37]

The purpose of the spectrum is to illustrate the full range of visible hues. No matter how many more intervals can be detected between yellow-to-red and yellow-to-blue than between red-to-blue, *no new hue is introduced*. Only intervals of value are added. To say that there are more hues between yellow-to-red and yellow-to-blue than between red-to-blue misunderstands the nature and purpose of the spectrum.

Chromatic Scales

A *chromatic scale* is a linear series of hues in spectrum order. A chromatic scale does not necessarily include all hues. A series between blue and orange (blue-green-yellow-orange) is a chromatic scale. The scale can illustrate pure (saturated) colors or more complex, diluted colors. The defining characteristic of a chromatic scale is that *each step in its progression is a change in hue*.

[37] An argument is sometimes made for expanding the spectrum with more steps (or intervals) in the yellow-to-blue and yellow-to-red ranges than in the blue-to-red. A color wheel illustrated in this way would have many more intervals of yellows, oranges and greens than of the reds, violets or blues. A spectrum illustrated in this way has an immediate problem in establishing complementary pairs (*See* Complementary Hues, below). So many possible intervals can be illustrated between colors in the yellow ranges that they might actually end up opposite each other on a circle.

Cool and Warm Colors

Cool and *warm* describe two opposing qualities of hue. Cool colors contain blue or green: blues, greens, violets, and steps between them. Warm colors are reds, oranges, yellows, and intervals between them. The warmth or coolness of a hue is sometimes called its color temperature. [38]

The primary colors are weighted toward warm. Only blue is cool, while red and yellow are both considered warm. As a result, the entire spectrum is more heavily "warm" than it is "cool." Blue is the polar extreme of cool, and orange, made of red and yellow, is the polar extreme of warm.

Warmth and coolness in colors are not absolute qualities. The same color can appear warmer or cooler depending on its placement. Any color, even a primary color, can be seen as warmer or cooler relative to another. Reds can be cool (closer to violet) or warm (closer to orange). Violet and green are generally considered to be cool colors, but it's possible to describe a sample of violet as warmer than another violet because it contains more red.

The terms "cool" and "warm" are helpful for describing families of colors or for comparing colors for warmth or coolness alone. They are less useful terms when hues need to be adjusted. Directing a color change toward a specific hue communicates more clearly: "This violet is too warm. Cool it off, reduce the red. This red is too cold. Warm it up; give it a shot of orange."

Analogous Colors

Analogy is a relationship between different hues. *Analogous colors* are hues that are adjacent on the artists' spectrum. The traditional definition of analogous colors is "a group of colors consisting of a primary color, a secondary color, and any or all hues that lie between the two." Analogous colors are among the most frequently used in design. Analogy offers the designer an enriched palette without making fundamental changes in the balance of a color composition. (*See* Figure C–6 in color insert.)

Analogous color groupings contain two primary colors but never the third. In the classic definition of analogy, a primary hue dominates the grouping: every color in the

[38] Not to be confused with the scientific concept of color temperature, which refers to the temperature in degrees Kelvin of a piece of metal called a blackbody as it heats and changes color. *See* Chapter 2. "A Little Light on the Subject."

group contains (visually) at least 50% of the primary. Some examples of analogy are:

Blue, blue-violet, and violet (blue dominant)
Blue, blue-green, and green (blue dominant)
Yellow, yellow-green, and green (yellow dominant)
Yellow, yellow-orange, and orange (yellow dominant)
Red, red-violet, and violet (red dominant)
Red, red-orange, and orange (red dominant)

The traditional definition limits the analogous relationship to colors that lie between a primary and a secondary. This restricts analogy to color groups in which a primary dominates. A more generous definition describes analogous colors as groups of colors that are adjacent on the color wheel; contain two, but never three, primaries; and have the same hue dominant in all samples.

This broader definition includes color groups in which a secondary color is present in all samples, like yellow-orange, orange, and red-orange (orange dominant). No matter which definition is accepted—the traditional one or the more generous one—it is not necessary for an actual primary or secondary color to be present for colors to be analogous. Analogy occurs when all elements in a color group contain a readily discernible common hue and only two primary colors are present. Blue-violet and blue-blue-violet are not primary or secondary colors, but they are analogous.

Analogy is not confined to pure colors. Colors that have been diluted in any way can also be analogous. Analogy is a relationship between hues no matter what their value or saturation.

Complementary Colors

Complementary colors are hues that are opposite one another on the artists' spectrum. Whether a spectrum is illustrated with six hues or ninety-six, a straight line drawn across the center of the circle connects two complementary colors. Together, the two are called complements or a complementary pair. The basic complementary pairs are:

Red and green
Yellow and violet
Blue and orange

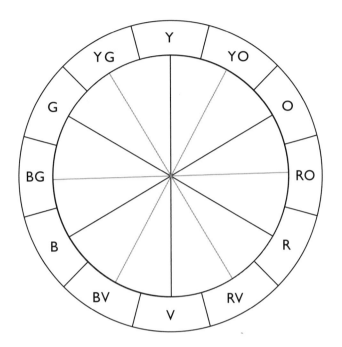

Figure 4–2 *Complementary Colors.* Complementary colors are opposite each other at any point on the artists' spectrum

Every pair of complementary colors contains the three primaries. In each of the three basic complementary pairs, one half is a single primary, and the other half is the secondary made of the remaining two. (*See* Figure C–1 in color insert.)

Another way to define complements is to say that they are a pair of colors that, when mixed, yield an achromatic neutral. Complementary colors mixed together absorb all wavelengths of light because they contain all three primary colors. Diluting a color with some of its complement in order to dull and darken it is a standard mixing technique in subtractive media (paints, dyes, crayon, pastel, etc.). (*See* Figure C–7 in color insert.)

The complementary relationship is fundamental to color vision, to special effects and illusions, and to color harmony. Every color has an opposite that is its complement. All complementary hues have the same attributes:

- A pair of complements used together at full saturation is jarring and fatiguing to the eye. [39]
- When complementary colors are mixed to the visual midpoint between them, the result is a an achromatic mixture.
- Complementary contrast is the foundation of simultaneous contrast and afterimage (*see* below).

[39] *See* Equilibrium, below.

The three basic complementary pairs are different from each other in the exactly the same way as the primaries. Neither color contains a hue in common with its opposite. All other complementary pairs are less contrasting because, like secondary colors, each half contains a hue in common with its opposite. Examples of complementary pairs that contain a common hue are blue-green and red-orange (each contains yellow); yellow-green and red-violet (each contains blue); and blue-violet and yellow-orange (each contains red).

Colors do not have to be pure hues to be complementary. Colors retain that relationship whether they are pure hues or have been diluted in some way. No matter what the value or saturation of a hue, it always maintains the complementary relationship with its opposite.

Equilibrium

When the three primary colors are present in the field of vision, the eye is in a state of *equilibrium*. Equilibrium isn't just a descriptive term. It is a physiological state of rest that the eye requires. Equilibrium depends on the presence of the additive primaries (colors of light) in the field of vision: the red, green, and blue wavelengths. The subtractive primaries red, yellow, and blue reflect these wavelengths, so they are identical in effect.

It is not necessary for the primaries to be present as equal areas for the eye to be at rest, just that all three be present in some mixture or proportion. The eye will accept any number of combinations of the primaries to reach equilibrium. Three primaries or two secondary colors can be present, or a pair of complements, or a single color that has been diluted by its complement (mixed into a muted hue). [40] Any situation in which the three primaries are displayed in some way allows the eye to be at rest.

Very brilliant colors, however, are an exception. Brilliant hues are disturbing to equilibrium. A number of brilliant hues in the field of vision deliver separate, strong and contradictory stimuli. The eye responds to each as if it were a single sensation. The struggle to maintain equilibrium causes vibration, headache, blurred vision and dizziness. This effect is strongest when the brilliant colors are complementary. (*See* Figure C–16 in color insert.)

The state of rest is reached most fully when the three primaries are mixed into muted hues. The slightest dulling of a pure color makes it less stimulating to the eye. The popularity of "earth" colors, which are hues muted almost to the point of being achromatic, may derive from the fact that they are genuinely, physically, restful.

[40] *See* Tertiary Colors and Saturation, below.

Simultaneous Contrast

When one or two of the three primaries is missing in the field of vision, the eye is not at rest. *Simultaneous contrast* is an involuntary response that occurs when the eye is not at rest. When the eye is stimulated by a single hue, adjacent neutral (achromatic) areas take on characteristics of the "missing" complement. *For any given color the eye will spontaneously and simultaneously generate the missing complement.*

The strongest effects of simultaneous contrast occur when the neutral (achromatic) area is completely surrounded by the stimulating hue. A gray paper square that is laid on a red background takes on a greenish cast. The same gray square laid on brilliant green appears as a rosy gray. (*See* Figure C–8 in color insert.)

Playing with paper squares is a classroom exercise, but in real life areas of adjacent color influence each other very strongly. A true story illustrates how disastrous the effects of unexpected simultaneous contrast can be.

> An interior designer selected a gray carpet for installation throughout an apartment. The client had been specific, insisting, "I hate blue, I only want gray." Together, client and designer selected a gray carpet. The apartment walls were painted in variants of "peach" and "terra cotta"—tints and shades of orange. When the carpet was installed, it was a muted, but definite, blue. The frantic designer brought a sample of the carpet back to the carpet showroom, insisting that the wrong goods had been installed. The sample was identical to her original selection. Simultaneous contrast was the villain. The orange-based wall colors caused the eye to generate the complementary blue, and the gray carpet was a perfect neutral area to receive blue, the missing complement.

Although simultaneous contrast is strongest when the stimulating hue is a saturated color or brilliant tint, muted, pale or darkened hues can also cause it to take place. Simultaneous contrast will occur to some extent whenever a single hue is placed on or next to an area that is neutral in color.

Simultaneous contrast is a factor in the selection of every neutral (including, and especially, white) that is intended for use with a single hue or family of hues. Fortunately, it is easy

Figure 4–3 *Afterimage and Contrast Reversal.* Stare at the larger black circle as long as possible without blinking. Then blink firmly, once, and look immediately at the black dot in the center of the white square. Try the same thing with the diamond design. What happens?

for designers to anticipate and counteract its unwanted effects. If a green textile is used against a white one, the white one must have a green undertone to counteract the red that the eye generates. Without the green undertone, the white will take on a pink cast. A red textile calls for a warm undertone in the white to negate the green that the eye supplies. If the designer in the example above had used a gray carpet with an orange undertone, the problem would never have occurred.[41]

Afterimage and Contrast Reversal

An *afterimage* is exactly what it sounds like: an image that appears *after* a stimulating hue has been taken away. Afterimage is caused by the same mechanism in the eye as simultaneous contrast, but it takes place under a more limited set of circumstances. For afterimage to occur there must be a stimulating color image that is viewed, then removed from view, and a nearby neutral surface on which the eye then experiences the image in complementary color.

Afterimage requires a stronger hue stimulus than simultaneous contrast. Simultaneous contrast occurs with muted colors, but it's almost impossible to generate an afterimage without strong color as a stimulus.[42] Afterimage is also called successive contrast.

Contrast reversal is a variation of afterimage. In contrast reversal the ghost of the original color appears as a negative. The stimulating image might be a pattern of bright yellow diamonds on a white page. When the image is removed and a blank white paper substituted, an afterimage of pale violet diamonds appears where the yellow diamonds were, and the white spaces between them appear yellow.

[41] Acknowledging the indignation that consumers have voiced when they have painted walls "white" only to see them as "pink" when green carpet is installed, paint manufacturers now provide charts showing various whites meant for use with green schemes, blue schemes, orange schemes and so on. The colors are formulated to prevent the surprises caused by simultaneous contrast.

[42] It has been said that black and white do not create afterimages, but it's demonstrated here that they do. The afterimage generated by black and white appears as a negative, like a photographic negative.

Complementary Contrast

Simultaneous contrast, afterimage, and contrast reversal occur when only *one* hue is present. *Complementary contrast* occurs with *two* colors that have even the slightest complementary relationship. When two colors with even a suggestion of complementary relationship are placed next to each other, that relationship will be emphasized. A blue-green sample placed with red appears more green. The same blue-green used with orange appears more blue. (*See* Figure C–9 in color insert.)

Complementary contrast is a powerful phenomenon. Muted colors that have even the slightest complementary relationship appear more intensely different when placed next to each other. If a rose-gray is placed next to green-gray, each appears more chromatic than if seen alone: a much redder rose-gray, a much greener green-gray.

Many times what seems at first to be simultaneous contrast is really complementary contrast. Grays, browns, and other neutrals nearly always include some hue content that is not apparent at first. Some grays contain blue, while others have an orange or brown undertone. So-called "beiges" have a warm undertone; neutral "putty" has a greenish cast. This hint of color makes them especially vulnerable to unexpected effects. The eye reinforces any complementary relationship, however slight, that already exists. (*See* Figure C–9 in color insert.)

Tertiary Colors: Muted Hues and Brown

Tertiary colors are an enormous, almost limitless class of colors. Tertiary means "of the third rank." Tertiary colors are defined as "gray or brown, a mixture of two secondaries" (*The Random House Dictionary of the English Language,* 1967, page 1466).

Tertiary colors are a sort of color soup, containing all possible hue ingredients but with no single hue apparent or dominating the mixture (although it should be possible for a trained eye to identify one or more of the hue ingredients).

A color that has been dulled slightly by the addition of its complement is a muted hue, not a tertiary color. Red dulled by the addition of a little green is still red. Tertiary colors are *chromatic neutrals*. They cannot be identified as hues, but neither are they a mix of black and white.

The word *brown* is used to describe many of the colors in this "not black, gray, or identifiable-color" family. Brown is not a hue. We say "brown" instead of "tertiary color" because it is common usage and equally descriptive. Brown typically has an orange or red content, rather than a cool one. Colors aren't more or less brown, but browns can be more or less red, or orange, or yellow, or even more blue or green. (*See* Figure C–7 in color insert.)

Black, White, Gray

Black and white are *achromatic*. They have no discernible hue. Grays, or mixtures of black and white, are also achromatic. Scientific methods exist for creating "pure" whites and blacks in light: light can be perfectly white, or a total absence of light can be completely black. But as a practical matter even the best colorants for black and white contain some suggestion of warmth (yellow, orange, or red) or coolness (blue, violet, or green).

Grays are generally categorized in this way—as warm grays or cool grays—rather than as "orange" grays or "blue" grays. Sometimes the coolness or warmth is very evident; at other times it can be detected only when the sample is compared to a different gray. When warm grays and cool ones are placed next to each other, complementary contrast makes differences between them instantly apparent.

Even if a gray seems truly achromatic, a nearby color causes the eye to invest it with some color. Grays provide an ideal field for simultaneous contrast to occur. (*See* Figure C–8 in color insert.)

Value

Value refers to relative light and dark in a sample. Hue is circular and continuous, but value is linear and progressive. A series of intervals of value, called a value scale, has a definite beginning and end. Value contrast exists whether or not hue is present. It is first and most easily understood in achromatic form, without the presence of hue:

Figure 4–4 *Intervals of Value.* Value is progressive. It moves from light to dark whether or not hue is present.

- Black is the lowest possible value.
- White is the highest possible value.
- Middle gray, the midpoint between black and
 white, is a middle or medium value, neither dark nor light.

In a value scale of even intervals from black to white, the progression from light to dark increases in ever-doubling steps. Each step of value in a series is twice as dark as the one before and half as dark as the one following.[43]

Value and Image

Only value contrast makes objects distinguishable from their background. Hue and saturation have little role in "readability." Black-and-white drawings, the printed page, and film images are perfectly clear without hue. People with a deficit in color vision are functional in a seeing world because "color-blind" really means "hue-blind," and hue is not a factor in the perception of image.

The amount of contrast between light and dark areas determines the strength or graphic quality of an image. Black and white, the extremes of value contrast, create the strongest images. When value contrast is very slight, images are difficult to see. When there is no value contrast—like an igloo in snowstorm—there is no image at all.

Discriminating between light and dark in achromatic samples is reasonably easy. Occasionally it's difficult to make a judgment about which of two middle value grays is lighter or darker, but this is usually resolved with little effort.

Transposing Image

Figure-ground perception requires no hue, only dark-light contrast. Images, whether they are black and white or color, are created by the *placement of different values relative to each other.* Even when the shapes or forms within a composition remain identical, scrambling the value relationships creates a different image.

A design may be printed in four values of blue on a white ground. In order to duplicate it in grays, in another color, or in multicolor, the new colors must maintain the same light-to-dark placements as those of the original blues-on-white design. (*See* Figure C–10 in color insert.)

Pure Hues and Value

Value is associated with the idea of *luminosity*. A color that is luminous reflects a great deal of light, appears light, and is high in value. A nonluminous hue absorbs light, is dark, and is low in value. It is immediately apparent that the saturated colors are at different

Figure 4–5 *Value and Image.* An image is most distinct when it contrasts in value with its background. When image and background are similar in value, the image is harder to see.

[43] Nineteenth-century studies in perception by Gustav Fechner and his predecessor E. H. Weber suggest that we perceive even intervals of value not as a mathematical progression (1, 2, 3, 4, 5, 6, etc) but as a geometric progression of ever-doubling steps (1, 2, 4, 8, 16, 32, etc.).

Figure 4–6 *Value and Image.* All of the butterflies have the same configuration, but changing the placement of values with each one makes them look different.

levels of value. It is also evident that *the six spectrum colors are not at even intervals of value*. Yellow is the lightest color by far, and violet the darkest. Red, orange, green, and blue are intervals of value, but *not evenly spaced* intervals of value, between the two.

Schopenhauer suggested a scale of luminosity for each of the six saturated colors. In Schopenhauer's color circle, each color is assigned a light-reflectance number value relative to the others (Albers 1961, page 43).[44]

Red	**Orange**	**Yellow**	**Green**	**Blue**	**Violet**
6	8	9	6	4	3

Yellow, the most luminous, is assigned "9," the highest number. Violet, the darkest of the pure colors, is assigned "3." Red and green are equal in value, and blue and orange are placed relative to the others. The Schopenhauer color circle is illustrated as arcs of unequal size, each arc meant to be equal in light-reflectance to the others. While this color circle recognizes the disparities in value between the saturated colors, the conclusion it draws is erroneous. A patch of saturated violet that is three times the area of a patch of yellow does not reflect the same amount of light as the yellow. The light-reflectance of colors is not a function of their area. What it does illustrate, very effectively, is the way we *sense* the value differences between pure colors.

Figure 4–7 *Schopenhauer's Harmonious Spectrum.* An imaginative concept about the light-reflecting values of the pure colors relative to each other.

[44] Itten attributes this number concept to Goethe (Itten1961, page 59), but it does not appear in Goethe's *Color Theory*. It seems likely that Albers' attribution is correct.

Tints and Shades

Colors are rarely used at full saturation. They are nearly always diluted in one or more ways. The simplest way to dilute pure colors is to change their value by making them lighter or darker. A *tint* is a hue that has been made lighter. A *shade* is a hue has been made darker. Tints are sometimes called hues with white added; shades are sometimes called hues with black added. "Added black" or "added white" is not necessarily meant as a recipe for paint mixing. "Added white" is another way of saying "made lighter," and "added black" is another way of saying "made darker."

Tinting a color retains the hue and makes it more light-reflecting. A great deal of added white creates tints that are barely identifiable as their original hues. Adding a small amount of white produces a strong tint that may seem more brilliant than the original saturated hue. Slightly tinted colors can be more intense color experiences than the saturated hues from which they derive. Violet, the darkest of the pure hues, appears more chromatic when white is added; the same can sometimes be true of blue, green, or red. Strong tints are sometimes mistaken for saturated colors, but no matter how hue-intense and brilliant a tint may be, it is a diluted hue—and no longer a saturated color.

Shades are reduced-hue experiences. Black absorbs all wavelengths of light, so adding black reduces light-reflectance. Black also mutes hues, dulling as well as darkening them. Slightly shaded hues are rarely mistaken for saturated colors. [45]

No one seems to have difficulty imagining (or illustrating) tints in any of the pure colors. The dilution of any color with white makes it more light-reflecting and more visible. Understanding and illustrating shades is a little more difficult. Shades of cool colors, like dark blue or dark green, are reasonably easy to identify, but shades of warm colors can be difficult to understand. Because saturated yellow is so light, many people find it particularly difficult to associate yellows (and oranges) with their shades. It is hard to imagine the combination of yellow or orange with black because the essential nature of yellow, whether alone or as a component part of orange, is so luminous and opposite to dark. But like all other hues, yellow and orange can be illustrated in the full range of values, from near-white to near-black. (*See* Figure C–12 in color insert.)

The range of shades is less familiar than tints, but it's just as extensive. Hue can be detected in a sample that at first appears to be completely black by placing it next to another,

[45] The word "shade" is often misused to mean hue, as in "that shade of red is more orange than this one." Shade is a word about value. It describes a color sample that contains a hue and black.

different black. Simultaneous contrast or complementary contrast make any hue present in the apparently "black" sample immediately apparent.

Tone

There's no satisfactory definition in the color vocabulary for "tone." *The Random House Dictionary of the English Language* (1967) gives it three consecutive and contradictory meanings. First, it's defined as pure color diluted by black or white, (which we know as a tint or shade). The second definition states that tone is "one hue modified by another" (as "this is a blue tone, that's a greener one"). The third meaning is given as "a hue muted by gray." Each definition means a modification of hue, but each means a different *kind* of modification of hue.

One word can't mean variation in value, hue, and saturation interchangeably. If the word tone is to be used at all, it requires more descriptive support—a darker tone, a bluer tone, a grayer tone—to make its meaning known. Used in this way, tone becomes a synonym for "object" or "sample." To refer to a "bluer tone," a "muted tone," or a "darker tone" implies comparison with other tones; other samples.

"Tone" is clearest in meaning when it is used as a verb, part of the phrase "tone down." To "tone down" a hue means to mute it, to reduce its saturation. No one ever says "tone up."

Monochromatic Value Scales

A single hue illustrated in intervals of tints and shades is a *monochromatic value scale*. Only one hue is present, but in any number of values. Monochromatic value scales are easy to understand and to illustrate. As with the black-gray-white value scale, the only difficulty might be in discerning differences between close intervals of value. (*See* Figure C–12 in color insert.)

Comparing Value in Different Hues

Deciding which of two gray samples is lighter or darker is not very difficult. Deciding which of two samples of a single hue is lighter or darker is equally straightforward.

Determining relative light and dark between different hues is difficult. It is more difficult when comparing value in warm and cool hues, and most difficult when the hues are

complementary. A homemade viewing paper isolates any two samples to be compared and makes the job easier.

Some color problems call for finding equal value in different hues. Only saturated red and green are close or equal in value. In order for other hues to be made equal in value to each other, one must be made darker or lighter. Adding a great deal of black to yellow can make it as dark as violet. Adding a great deal of white to violet can make it as light as yellow.[46] (*See* Figure C–11 in color insert.)

Figure 4–8 *A Viewing Paper.* A home made viewing paper isolates samples for comparison. Any opaque white paper with a small hole cut in it works well.

Saturation

Dilution of a saturated color by black or white causes a change in value, or light-reflectance. Value is about *light* intensity. The final descriptive quality of color is *saturation*, or *chroma*. Saturation refers to *hue* intensity, or the contrast between dull and vivid.

A *saturated* color is a color at its fullest expression of hue. *Saturation* is a comparative term. A saturated color is said to be a color at *maximum chroma*. When saturation is

[46] A particularly difficult exercise is charting the spectrum as a block of hues in *even intervals of equal value*. Each horizontal strip illustrates the six hues equal in value to each other. Each vertical strip is a single hue in equal intervals of value. The chart can be made using any number of hues and any number of value steps, but because the pure hues are not evenly spaced intervals of value, charting them in a fixed number of steps can be done only by using some hues as tints or shades, but not including them as saturated colors. *See* Exercise V-7 in the Workbook.

reduced, a color retains its hue identity. It may or may not change in value, but it is less *vivid*. Its chroma is reduced. (*See* Figure C–13 in color insert.)

A brilliant color can be—but is not necessarily—a saturated color. Brilliance in common usage describes both saturated colors and some strong, clear, light-reflecting tints. Red-violet diluted by a little white is a brilliant color, but it is a tint, not a saturated color.

As long as a dull-color sample can be identified as a hue, it *is* a hue, just one that has been reduced in chroma. A dull orange is still orange. When a color is so dull that the hue cannot be identified—when it has effectively lost its hue identity—it is a tertiary color. Hues in the tertiary ranges are not clearly defined. This is a classic situation for an argument set off by differences in individual ideas about colors: Jane's idea of "brown" is Alice's "burnt orange." (*See* Figure C–7 in color insert.)

Saturation: Diluting Pure Hues with Gray

One way to change the hue intensity or saturation of a hue *without* changing its value is by diluting it with a gray of equal value. When a sample of pure orange and a gray of equal value are the two "parents" in a parent-descendant color mixture, the middle mixture between the gray and the orange, the "gray-orange," is a muted hue, duller than the pure orange and more vivid (more chromatic) than the pure gray. It is also the same value as its two parent colors: neither lighter nor darker.[47]

Hues diluted with gray have a misty, filmy, appearance. Hues can be grayed very slightly or a great deal and still retain their hue identity. (*See* Figure C–14 in color insert.)

Saturation: Diluting Pure Hues with the Complement

A second way to dilute a pure color is to add its complement. Adding the complement to a color to reduce its saturation and value is a time-honored technique in the fine arts. Muting colors by adding the complement results in an enormous range of colors, from barely-muted hues to tertiaries.

A color that is diluted by its complement is changed in two ways. Chroma is reduced (hue is muted), and value is reduced. The new color loses light because the mix absorbs more wavelengths than either of the colors alone. Subtractive mixtures of violet and yellow are an exception. Yellow is so high in value that a mixture of violet and yellow is lighter than pure violet.

[47] When mixing a color and a gray of equal value in paints, the "descendant" color almost always appears darker than either of its parents. Paints must be mixed by trial and error to get the desired *visual* result (in this example, usually by the addition of white).

When steps between complements are determined *visually*, each pair of complements is a unique progression. Visual logic doesn't allow us to imagine the middle mix of each of these pairs as the same. Whether a series of intervals between complements is illustrated with paints, papers, pure light or pure imagination, each pair moves in steps to a center that is distinctly different from the others. Seeing color with visual logic means that the middle mix of orange and blue is not the same as that of violet and yellow.[48] (*See* Figure C–7 in color insert.)

Colors diluted by the complement are much more a part of our visual experience than colors muted by the addition of gray. The natural world is a chromatic experience, not a black and white one. Black and white are rare in nature. Johannes Itten points out, "Nature shows such mixed colors very elegantly" (Itten 1970, page 50), as when green fruits ripen to red or leaves turn from green to brilliant red in the fall.

REFERENCES

Albers, Josef. 1963. *Interaction of Colors*. New Haven: Yale University Press, 1963.

Goethe, Johann von Wolfgang. *Goethe's Color Theory*. Translated by Rupprecht Matthei. New York: Van Nostrand Reinhold Company, 1971.

Itten, Johannes. *The Art of Color*. Translated by Ernst Van Haagen. New York: Van Nostrand Reinhold, 1960.

Itten, Johannes. *The Elements of Color*. Edited by Faber Birren. Translation by Ernst Van Haagen. New York: Van Nostrand Reinhold, 1970.

Itten. Johannes. *The Basic Course at the Bauhaus, Revised Edition*. London: Thames and Hudson (also Litton Educational Publishing), 1975.

Ostwald, Wilhelm. *The Color Primer*. New York: Van Nostrand Reinhold, 1969.

The Random House Dictionary of the English Language. Jess Stein, Editor-in-chief. New York: Random House, Inc., 1967.

[48] *Theoretical gray* is a concept used by color theorists to describe an imaginary perfect tertiary color; one of no detectable hue. Theoretical gray (if it existed) would be created by the mixture of any pair of complementary colors. If theoretical gray could be illustrated, the middle mixes of violet and yellow, red and green, and blue and orange would be the same. Visual logic—and the limitations of light, viewer, and colorants—make theoretical gray a intellectual concept, not a reality. The middle mix of each pair of complements is different from the others. Theoretical gray is very much theoretical, very little gray.

Using Color

5

Color Composition / Ground and Carried Colors / Ground and
Graphic Quality / Image, Motif, Pattern, and Optical Mixes / Line
and Mass / Vibration / Vanishing Boundaries / Fluting / Transparency
and Transparence Illusion / Spatial Effects of Colors / Color and
Area / Texture / Placement and Color Change / Ground Subtraction
/ Reversing the Illusion: Two Colors as One / Influenced and
Influencing Colors / Spreading Effect

Color Composition

A *composition* is a complete entity; something that is meant to be sensed as a whole. A
design composition is a planned arrangement of forms and colors that is meant to be
sensed as a whole. A design composition is understood as separate from its setting and
from other things around it. The word "design" alone is used interchangeably to mean
a design composition.

Colors that are used together create a color composition: *a group of colors meant to be
sensed as a whole*. A group of colors selected for use together is called (depending on the
industry or design discipline) a *palette*, a *colorway*, a *color story*, or some other collective
term. Forms, colors, and their arrangement have equal importance in design. There is
no rule about what comes first in the design process. Establishing a palette can be a first
step or the final one.

Ground and Carried Colors

The background of a color composition is its *ground*. Different industries use different
terms for ground. Colors printed on fabric or wall covering are said to be printed on a
ground, but the background of a carpet or a banner is called the *field*. The paper used in
printing materials is called *stock*. A printer asks if he will be printing on "white stock,"
or "blue stock," "coated stock," or "uncoated stock."

No matter what each industry calls it, "ground" means the background when color
relationships are discussed. Colors laid *on* a ground are *carried colors*. Ordinarily a ground
is thought of only in terms of two-dimensional compositions, but background exists for

Figure 5–1 *Ground and Area.*
Ground is not necessarily the
largest area in a composition.
Other visual cues, like arrange-
ment and figure-ground
perception, determine what is
understood as ground and
what is understood as image.

Figure 5–2 *Ground and Carried Color.* Ground can be ambiguous. Is a zebra black with white stripes, or white with black stripes?

Figure 5–3 *Negative Space.* The unfilled area of a design—and its color—is as important in a color composition as the filled area.

all things. A red house seen against green trees is red seen against a green "ground"; clouds are white seen against the blue "ground" of the sky.

Ground establishes the visual reference point for carried colors. It is a critical element in color compositions that is often overlooked.

The area of design that is the ground is determined by composition, not by color or relative area. The ground is not necessarily the largest area in a composition. Carried colors may cover substantially more area than the ground. Visual cues and the arrangement of forms determine which parts of a composition are identified as image or pattern and which part is understood as background.

Sometimes it's difficult or impossible to distinguish between ground and carried colors. Is a zebra black with white stripes, or white with black stripes? A checkerboard with equal blocks of different colors or a striped textile has no defined ground. Creating a design in which the ground is ambiguous can be a deliberate choice.

Negative space is the area in a composition that is not part of the image or pattern. It is the "unfilled" area around, and sometimes within, the design elements. Negative space is often, but not always, the same area as the ground.

Ground and Graphic Quality

Graphic quality is the "readability" of a composition, or how clearly images can be seen against their ground. Only differences in value—contrasts between dark and light—separate images from their background. Black and white create the most value-contrasting, and, therefore, the most graphic, images.

White grounds give sharpness and clarity to any design, even if the carried colors are muted colors or tints. Black grounds also provide a strong contrast, particularly behind light colors, but nothing is comparable in sparkle and crispness to the effect produced by colors on a white ground.

Reducing the value contrast between a ground and its carried colors lessens the graphic impact of a composition. It makes no difference whether the ground and carried colors are brilliant hues, muted hues, achromatic, or contrasting in these qualities. The more

similar in value the ground and carried colors, the more difficult it is to discern an image. The more value contrast between them, the more visible the image.

When a ground and its carried colors are close in value, the overall effect is softened. The colors may feel "flat," lacking depth or crispness. Sparkle can be added without disrupting the balance of the palette by the introduction of lines or small patches of white or near-white. Depth is added by introducing black or near-black. No matter how proportionally small the areas of dark or light may be, or what their placement, their presence will enliven a flat composition. (*See* Figure C–15 in color insert.)

High-contrast images are not always desirable. Strong contrasts of dark and light provoke lateral inhibition.[49] When lateral inhibition occurs, the eye is *working*. Viewing high-contrast images over a sustained period causes eye fatigue. Superhighway signs are dark green and white rather than black and white because dark green and white provide good contrast at a slightly reduced level, decreasing the risk of eye fatigue—and accidents.

Image, Motif, Pattern, and Optical Mixes

The distance from which something ordinarily is seen is always a factor in its design. Designing graphics for a telephone directory assumes a close viewing distance. Designing wallpaper presupposes a middle distance; highway billboards, another viewpoint entirely. An *image* is a picture, whether it is simple or elaborate. A *motif* is a simple image (or figure) that is a color mass, an area enclosed by line, or a combination of these. A motif can be representational or nonrepresentational; a flower, for example, or a "blob." The actual size of a motif is unimportant; it is simply a design element that can be perceived as a single element against a ground. A motif *repeated* against a ground is a *pattern*. A pattern can be regular or random, geometric or fluid. Pattern is sensed as a whole, but the individual motifs that make it up can be separately distinguished.

There is a point at which multiple motifs become too small and closely spaced to be seen as pattern. *Optical mixes* result when two or more colors, in masses too small to be perceived separately, converge in the eye to create an entirely new color.

Whether a design is seen as image, pattern or texture depends on the *scale of its design elements relative to the viewing distance*, not on the actual size of the design elements. A "dot" in an optical mix on a billboard may actually be the size of a book page when it is seen at closer range.

[49] *See* Chapter 3, "The Human Element"

Figure 5–4 *Graphic Quality.* Graphic quality (the strength of an image) depends on value contrast. The strongest images contrast sharply in value with the ground. Image are weaker when image and ground are similar in value.

Because an optical mix is a combined color, the qualities of its component colors control its final effect. If the colors contrast in value, (and most do), the resulting surface will give an impression of texture. A mix of yellow dots, which are light, and red dots, which are darker, produce a lively orange surface, not a flat field of color. Complementary colors combined as dots appear muted. Optical mixes of analogous hues yield a vibrant, dynamic surface.

A flat surface of a single color is static. A flat surface covered with tiny patches of colors dances with energy. The Impressionist painters used optical mixing to create new hues, tints, shades and shading without mixing paints. The French painter Georges Seurat called optical mixing "divisionism."[50] In divisionism, the colors on the canvas were pure colors or tints, laid on in tiny dots that fused in the eye to create new colors.

Most color printing is achieved with optical mixing. Dots of ink on paper, too small to be seen individually without a magnifying glass, merge in the eye to create a color image. *Monitor screen colors are optical mixes.* Although light is mixed within each pixel to produce a full range of colors, a single pixel is too small to be seen as a color mass. The thousands of individually-colored dots merge in the eye as the hues, tints, shades, and shadings of the screen display.[51]

Line and Mass

A form (or image) can be seen as long as there is value contrast between a color mass and its ground. Differences between areas may be intensified by contrasts of hue or saturation, but only differences in value create "edge" between blocks of color.

Line is an elongated area of contrast laid against a ground. There are thicker lines and thinner ones, broken lines and lines of varying width, but they have one common attribute: great length in relation to little width.

Line is usually thought of as being dark or black, but it can be any hue, value or saturation. Black line on a white page creates a strong image; dark gray line a weaker one; pale gray line hardly any image at all.

Lines that contrast sharply with their ground have tremendous visual power. Two blocks of color that are similar in value are difficult to make out, but the thinnest contrasting line drawn between them creates an immediate separation. (*See* Figures C–16 and C–17 in color insert.)

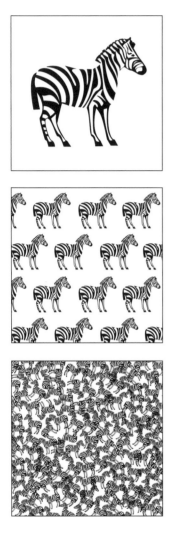

Figure 5–5 *Image, Pattern and Texture.* The size of an image and the distance from which it is seen determine whether something is understood as an image, a pattern, or a texture.

[50] His style of painting is now better known as "pointillism."

[51] *See* Chapter 7, "Tools of the Trade."

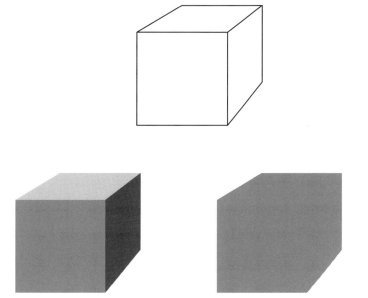

Figure 5–6 *Line and Mass.* Blocks or masses of color that contrast in value with the background define forms and space. Although line occupies very little area, it also defines forms and space by creating a contrast of value.

Vibration

A composition of two or more brilliant and contrasting hues is initially exciting, but the excitement is short term. Discomfort follows quickly. Saturated colors and strong tints have great hue-intensity, or brilliance, and are highly stimulating to the eye. When the eye is forced to seek equilibrium in opposite, contradictory ways at the same time, color masses lose their edges and appear to shimmer, an experience called *vibration*. Pale tints, muted colors, and shades don't stimulate the eye in the same way.

Vibration occurs strongly with complementary colors, like blue and orange, or near-complements, like blue-green and orange. It is most intense when the contrasting hues are *equal in value*. Without value contrast between blocks of color, it's difficult to see the edges. The struggle to focus on edge, added to the struggle to reach equilibrium, becomes a miserable visual experience.

A second, (and equally uncomfortable), kind of vibration results from poor *scale* in a pattern relative to its viewing distance. When individual motifs in a pattern are just smaller than can be comfortably discriminated individually, but slightly too large to merge into

texture, the eye makes repeated attempts to focus. It holds the image briefly, then must refocus. Poorly scaled wallpapers, particularly checked patterns, are frequent offenders. No hue is needed for this kind of vibration to occur. Vibration caused by poor design scale occurs whether a composition is colorful or achromatic. Aesthetic experiments like the "Op" (optical) art of the 1960s are a powerful illustration of ways in which color and scale can be manipulated to create visual disorientation.

When a palette of brilliant colors of similar value is important to a design; vibration can be reduced or eliminated by introducing darker or lighter line between the colors. (*See* Figure C–16 in color insert.)

Vanishing Boundaries

Vanishing boundaries occur when blocks of *similar* hue and *equal value* are placed next to (or laid on top of) one another. Each color seems to merge into the other and lose its edges. The illusion occurs only when colors are masses or blocks. The thinnest line of contrasting value between them ends the illusion. (*See* Figure C–17 in color insert.)

Figure 5–7 *Fluting.* Fluting is an illusion that occurs when stripes are arranged in even, progressive steps of value.

Fluting

Fluting is a illusion in which a series of vertical stripes of uniform width appear to have concavity, like the channels of a Doric column.[52]

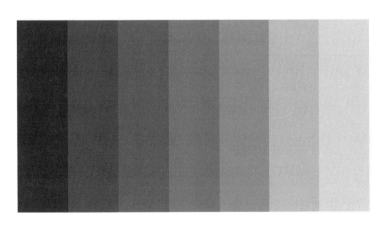

Fluting occurs when stripes are arranged in a series of progressive steps of value. Each stripe is an even interval of value between the "parent" stripes on either side of it. The "parent" stripes act as grounds: the edges of each stripe appear lighter where it abuts its darker "parent" and darker where it abuts its lighter "parent."[53]

Like the three bears' porridge, the stripes have to be just right. If they are too wide, the eye can't take in both edges at the same time. If they are too narrow, they will appear to be lines instead of blocks of color.

[52] Wide stripes sometimes give an illusion of convexity, but the effect is still called fluting.

[53] *See* Ground Subtraction, below

A spectrum of saturated colors that is arranged as stripes appears fluted, but only because the colors are progressive in value. Each "parent" stripe also subtracts its own *hue* from its neighbor: an orange stripe seems more red along its edge next to yellow; the opposite edge, next to red, seems more yellow. Changes in hue along the edges reinforce the fluted effect that is caused by the progression of changing values. Stripes of different hues in which the values are equal do not appear fluted.

Transparency and Transparence Illusions

Transparency in color can be a fact.[54] Transparent liquids appear stronger in hue as their volume increases, a phenomenon Josef Albers describes as "volume color" (Albers 1963, page 45). There are opaque liquids and transparent ones. A strawberry milkshake (opaque) is the same color in a gallon container as it is in a cup. Coffee (transparent) in a deep pot is very dark, but coffee spilled in a saucer is as light as weak tea. Transparent media allow light to pass through the colorant and reflect back from white paper underneath. As layers are added, the transparency decreases and the covered areas become darker. These are true transparencies, not illusions.

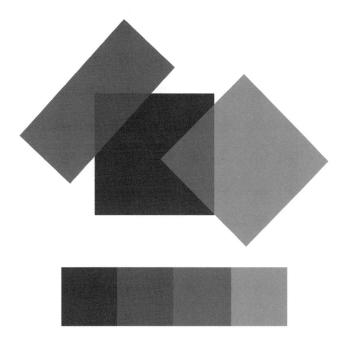

Figure 5–8 *Transparence illusion.* An illusion of transparence depends a series of intervals between colors that have been arranged in a certain way. The same grays, arranged in series, show no effect of transparency.

[54] "Transparent" liquids are actually *translucent*: they transmit some wavelengths of light and reflect others. The word "transparence" is used to mean "translucence" by most writers about color. It is used here in that way to avoid conflict with other texts.

Some hues, even if they are opaque, suggest transparency. Cool hues, especially tints of blue and green, often seem transparent. Warm colors, particularly those containing red, appear more dense.

An illusion of transparency is astonishingly easy to create using opaque colors. Any parent–descendant color mixture (two colors and the middle interval between them) that is arranged as if the parent colors were crossing one another, with their middle interval placed in the area where they overlap, creates the illusion that a transparent color is lying on top of an opaque one.

Relative value determines which of the two colors appears to be lying on top of the other. No matter what the hues, the lighter of the two parent colors will appear to be on top (transparent), and the darker color underneath it (opaque). (*See* Figure C–18 in color insert.)

Spatial Effects of Colors

Color influences whether objects are perceived as larger or smaller, or as advancing or receding. Another way to describe "advancing" and "receding" is to call it "near and far." Some colors have inherent qualities of "nearness" or "farness." Light blues seem to move away, and warm colors of any value close in.

An object can be made to appear larger, smaller, nearer, or farther away by making a change in its hue, value, or saturation. *In general*,

> Warm colors advance relative to cool ones. Your right foot, in the red shoe, looks larger than your left foot, in the green one.

> Brilliant colors (saturated hues and strong tints) advance relative to more muted ones. The magenta elephant seems a lot bigger and closer than the gray one. (*See* Figure C–19 in color insert.)

> Objects in light colors appear larger than the same objects in dark colors. A white bear looks bigger (and closer) than a black one standing in the same spot. However, when dark and light samples are laid against the same ground, *the color that has a greater contrast in value with the ground will advance, and the color closer in value to the ground will recede*. Dark colors advance relative to light colors on a light ground; light colors advance relative to darks on a dark ground.

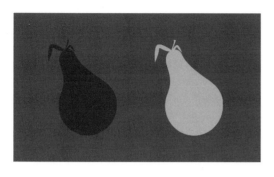

Figure 5–9 *Spatial Effects of Colors and Value.* Colors that contrast in value with the ground advance in relation to those that are closer in value to the ground. Dark colors come forward on a light ground; light colors come forward on a dark ground.

The key to understanding whether colors will advance or recede in relation to one another is in the phrase "*all other factors being equal.*" Combinations of colors in which "all factors are equal" except one are rare. The *dominant* quality of a sample—its warmth, high value, or brilliance—determines whether it will seem to move forward or back relative to other colors. In a gray world, yellow will bounce forward. In a black world, gray will glow with light.

Color and Area

The *extent* of a color affects how it appears. A single color that is selected from a small sample changes its appearance when it is seen as a larger area (and vice versa). This is an issue faced more often in architecture and interior design than in other design fields.

Selecting color for a large area—and getting it right—is closely related to lighting conditions. The color quality of a lamp (its spectral reflectance), of course, matters

in all color rendition, but when a designer specifies color for large surfaces, the *quantity* of light and the *direction* from which it reaches the surface also matter.

Colors selected from small chips and applied to a large plane undergo a shift in value. The direction in which value changes (to lighter or to darker) depends on the placement of the surface in relation to the light source. As a general rule, floors and walls appear lighter, and ceilings darker, than a small sample of color in the hand. For example, a designer selecting a pale blue for a ceiling must use a paint that is two or three intervals lighter in order to achieve the color of the sample in hand. A house painted with the darkest brown from the paint chart appears closer to medium-dark brown. Charcoal gray, which is nearly black on a chart, is a medium-dark gray when applied to the sides of a house.

Colors also seem more *chromatic* when seen in a large area. Light and dark colors are equal in this effect. A spectrum blue, applied to walls, is overwhelmingly blue. "Cream" yellow house paint is always yellower than expected. Muting color that is applied to a large area generally brings it closer to the perceived color of the small sample.

Texture

A (real) textured surface scatters light in many directions, and light reflected off it reaches the eye as a pattern of tiny patches of light and dark.

An *impression* of texture on a flat surface is created by using a number of different values in an optical mix. Darker "dots," or patches of color, recede; lighter ones advance; and middle values create a matrix for the advancing and receding dots. The size and shape of the dots in the optical mix determine whether the texture will be seen as coarse or fine. Tiny dots produce an impression of fine texture, like sandpaper. Coarser textures are illustrated by using larger and more irregular patches in the optical mix.

Placement and Color Change

Light is the first modifier of color perception. Colors change under different light sources because of the interaction between the light source and the colorant. Changes in color caused by changes in light are difficult for the designer to predict or control.

The second cause of color change is the interaction between grounds and carried colors.

Figure 5–10 *Texture.* Tiny spatters of dark and light give an impression of texture on a flat plane.

Whenever two or more colors are placed next to,(or on top of), each other, each color affects the other in predictable ways. The choice of ground color determines how carried colors will appear; the reverse is also true—carried colors affect the way the ground is seen.

These changes are caused by placement. Changes caused by placement can be controlled by the designer. They are also tools used to create special effects and illusions. Uncertainty about which area of a design is the ground and which area is carried color doesn't lessen the effects that colors in a composition have upon each other. The colors of ground, negative space, and images, and patterns are equal in their power to effect change.

There are three ways in which placement causes change. Two are already familiar:

Simultaneous Contrast	The ground or the carried color is a *single hue*; the other is *achromatic*. The achromatic area takes on qualities of the complement. A gray square on orange seems blue-gray, but the same gray square on blue appears warmer and more orange-gray. (*See* Figure C–8 in color insert.)
Complementary Contrast	The ground and the carried colors include elements that are *complementary*. Differences in hue (however slight) are emphasized. A cool gray is laid on brown. The gray contains a hint of blue, the brown ground, a bit of orange. Used as ground and carried color, each appears much less gray, and much more chromatic. (*See* Figure C–9 in color insert.)

Simultaneous contrast generates a difference between samples when only one hue is actually present. Complementary contrast accentuates the difference between two samples that contain complementary, opposing hues. Simultaneous contrast and complementary contrast are effects of hue alone, and each intensifies differences between samples that are already unlike.

Ground Subtraction

Ground subtraction is completely different. It intensifies the differences between colors that contain qualities *in common*.

Any ground subtracts its own qualities from colors it carries. Common qualities of hue, value, or saturation are reduced. The differences between them are emphasized. Ground subtraction affects hue, value, and saturation equally. Ground subtraction asks three questions:

- What qualities of hue, value, and saturation does each carried color *share* with the ground?
- What qualities are *reduced*?
- Finally, what qualities are *left*?

The simplest illustration of ground subtraction is made up of three grays: a dark, a light, and the middle interval between them. The middle gray is cut in two, and one piece is placed on each parent color. The middle gray placed on dark appears lighter; its common darkness is reduced and its remaining lightness is intensified. The same middle gray on the light ground appears darker; its lightness is reduced and its remaining darkness is emphasized.

The example above illustrates only the subtraction of value. Hue and saturation are equally susceptible to change by placement. Blue-green placed on blue appears greener; the blue common to both is reduced and the remaining green is emphasized. The same blue-green placed on green appears bluer; the common green is reduced and the blue is intensified. A reddish gray placed on gray appears more red. Placed on red, a reddish gray appears much grayer. (*See* Figure C–20 in color insert.)

Figure 5–11 *Ground, Value, and Illusion.* A middle-value gray appears darker when it is placed on a light ground and lighter when it is placed on a dark ground.

Ground subtraction is one of the great weapons in a designer's arsenal. In many kinds of printing the number of colors used is a factor in cost: the more colors, the higher the production cost. Textiles, wallpapers and solid-color printing are examples. Ground subtraction enables the designer to make a few colors seem like many more by placing them strategically. Three printed colors are easily made to look like five (or more) by placing them on each other as well as directly against a (white or colored) ground. Production costs are contained, the color composition is richer—and so is the manufacturer. (*See* Figure C–21 in color insert.)

Reversing the Illusion: Two Colors as One

Two different colors can be made to appear to be identical by placing them on different grounds. The ground for each is chosen to reduce some qualities and intensify others. A green and a yellow-green can be made to look as if they are the same color by placing them on grounds of opposing qualities. Yellow-green placed on yellow appears more green because the common yellow is reduced. A "greener" green (containing less yellow) placed on a blue-green ground will appear more yellow; the blue present in both is reduced. (*See* Figure C–22 in color insert.)

Whenever two colors are planned for use together there is a potential for change. This is true in the fashion industry for textiles, in graphic arts for print and paper colors, and in home furnishings for textiles, paint and carpet. The changes caused by simultaneous contrast, complementary contrast and ground subtraction are constant and predictable. They influence every color composition. They are as much positive forces as they are effects to be prevented because unlike the changes caused by light, *changes caused by placement can be controlled by the designer*.

Influenced and Influencing Colors

No colors are inherently more "influencing" or "influenced." Any color can be changed by placement, and all colors have the power to effect change in other colors. The colors that change most *often* are colors that are subject to more than one influence. Complementary contrast and ground subtraction (or simultaneous contrast and ground subtraction) can be in force at the same time. But this seems contradictory. How can colors be both alike and different? How can colors contain opposite and common qualities at the same time?

Imagine a "brown" square, a mixture of blue and orange. Placed on an orange ground, the orange will be reduced. The blue component will be intensified *twice*: first as the color remaining after the orange is reduced, then by complementary contrast against the orange ground. The same brown square, placed on a blue ground, will look very much more orange as the blue is reduced and the orange intensified.

The more complex a color is—the more elements it contains—the more likely it is to include qualities that are opposite to *and* qualities that in common with nearby colors. The changes that take place with complex colors are not necessarily more dramatic than those that take place with simpler colors. A "primary" red can be made to appear distinctly more orange or more violet by placing it on different grounds. The changes in "browns" (tertiary colors) occur more *frequently* because these colors contain so many elements that can interact with their color neighbors.

Color is the stuff of sorcery. Colorists use simultaneous contrast, complementary contrast, ground subtraction, optical mixes, varying intervals of value, and tricks of scale to achieve magical effects. Special effects of color like vanishing boundaries, fluting, transparence illusion and vibration are dependent on two conditions. First, blocks or masses of color must be juxtaposed *without the interposition of line*. Second, each effect depends on the placement of colors in relation to each other. For each of these illusions to occur, the blocks of color must be arranged in a specific way.

Spreading Effect

Spreading effect [55] was first noted by Wilhelm von Bezold, a German physicist, in 1876. (Goldstein 1984, page 272). Spreading effect is different from other illusions because it is caused by line, not mass. It occurs when the balance of a composition is altered by adding, removing, or changing *one color only*; and when that changed color is present in the design as *line*.

Spreading effect, dependent on line rather than mass, creates changes that are the opposite of ground subtraction.[56] When a dark-line drawing is put onto a middle-value ground (a hue or a gray) the ground itself appears darker. If white or light line is substituted for the dark, the ground will appear lighter. The lightness or darkness of the line seems to "spread" into the ground. (*See* Figure C–23 in color insert.)

Spreading effect in a multicolor composition happens when design elements are *outlined*, or separated from the ground by dark or light line. When the internal forms are enclosed

[55] Also called "Bezold Effect."

[56] Some authorities have argued that the effect of the apparent shift in the ground color is not from dark to light, but from more blue to more yellow (or vice versa). Students should make their own observations—and draw their own conclusions.

by dark line, all colors appear darker. When the forms are enclosed by light line, all colors appear lighter. A dark or light outline affects the value of all colors in a composition.

REFERENCES

Albers, Josef. 1963. *Interaction of Colors*. New Haven: Yale University Press, 1963.

Goethe, Johann von Wolfgang. *Goethe's Color Theory*. Translated by Rupprecht Matthei. New York: Van Nostrand Reinhold Company, 1971.

Goldstein, E. Bruce. *Sensation and Perception*. Belmont, CA: Wadsworth Publishing Company, 1984.

Hope, Augustine and Margaret Walch. *The Color Compendium*. New York: Van Nostrand Reinhold Company, 1990.

Itten, Johannes. *The Art of Color*. Translated by Ernst Van Haagen. New York: Van Nostrand Reinhold, 1960.

Itten, Johannes. *The Elements of Color*. Edited by Faber Birren. Translation by Ernst Van Haagen. New York: Van Nostrand Reinhold, 1970.

Munsell, Albert Henry. *A Grammar of Colors*. New York: Van Nostrand Reinhold, 1969.

Ostwald, Wilhelm. *The Color Primer*. New York: Van Nostrand Reinhold, 1969.

Color Harmony / Color Effect

Color Harmony

Color harmony is the beauty or "pleasingness" of a *group* of colors. It is the collective impression of colors used together—the overall effect of a color composition. Johannes Itten defines color harmony as "the joint effect of two or more colors" (Itten 1961, page 21).

Harmony implies beauty, but beauty is only one possible outcome of combining colors. "The joint effect of two or more colors" is too comprehensive a phrase to confine to harmony. The phrase also describes color combinations whose impact is powerful for other reasons. More questions arise about any grouping of colors than "Is it pretty?" Is a combination startling, or visually aggressive? Is it restful and soothing? Boring, or monotonous? Is it dissonant, or disturbing? Does looking at it bring on a feeling of vertigo or a splitting headache?

"The *pleasing* joint effect of two or more colors" is a closer definition of color harmony in its traditional sense. Unfortunately, the only rational standard for a pleasing combination of colors is that someone is pleased by it. Since everyone has different favorite colors, the idea that a favorite combination might be aesthetically "unlawful" seems absurd (this hasn't prevented color theorists from asserting it; Albert Munsell used the work "admissible" in describing certain colors).

A more inclusive term for the force of colors used together is color *effect*. Successful color combinations are realized in terms of goal. Instead of thinking about color groups as harmonious, they can be thought of as successful or unsuccessful. What was the colorist trying to achieve in combining the colors? High visibility? A sense of luxury? Is an image more or less powerful for having been rendered in certain colors? Color effect encompasses the central issue of color use:

What makes a group of colors work together to solve the problem at hand?

Color effects fall into two categories. The first is *color harmony*, the traditional idea of beauty or pleasingness of colors in combination. The second is *visual impact*: the effect of color combinations on the visual power of a design or image.

The Historical Background

The search for laws of harmony in color combinations is a relatively modern idea. During the eighteenth century in Europe, in an historical period known as the Enlightenment (or the Age of Reason), there was a fresh and vigorous search for rational, rather than mystical, explanations for all kinds of natural phenomena. People began to believe in the existence of irrefutable laws of nature, and it was assumed that there were natural laws for everything, including color. Certain colors used together were inherently harmonious, and the laws for them, like laws of gravity, only awaited discovery. This search for causes was as rigid and uncompromising in its way as the demands of absolute faith that preceded it. Only the source of authority had changed, from God and his earthly representatives, the clergy, to reason and its earthly representatives, men.

The intellectual world of the eighteenth century was quite fluid. People didn't think of themselves as writers, biologists, or mathematicians but as "natural philosophers," "theologians," or "geometricians," all with wide-ranging and overlapping areas of interest. Poets and literary figures wrote confidently, if with dubious expertise, on all kinds of scientific topics. Most of those who studied and wrote on color in this period were not artists. Poets poised at the edge of the sciences, they sought a rational basis for the nature of beauty itself and, as a corollary, color. In this way the "behavior" of colors could be explained and predicted, and the mystery of observed color phenomena mastered through an understanding of natural laws.

Two themes dominated eighteenth- and nineteenth-century color study. The first was the search for a perfect color-order system; the second, the search for laws of harmony in color combinations. Just as there are classics in literature, there are classics of color writing. These treatises, dating from the late eighteenth century and continuing into the present day, make up the collective body of knowledge known as *color theory*. Two towering and very different men dominate the beginnings of this discipline: Isaac Newton (1642–1727) and Johann von Wolfgang Goethe (1749–1832). Their writings are the foundation of modern color study.

Newton, working at Cambridge in the late 1690s, first split sunlight into its component wavelengths by passing it through a prism. Newton observed that as each wavelength enters a prism it bends (or refracts). Because glass, the material of the prism, slows each wavelength down at a slightly different rate, each one emerges as a visibly separate beam of light, a different color. Newton recombined the separate beams with a lens and reconstituted white light. From this, he hypothesized the nature of light and the origins of perceived color. He published his results, entitled "Opticks," in 1703. Newton's conclusion that light alone generates color remains a basis of modern physics.

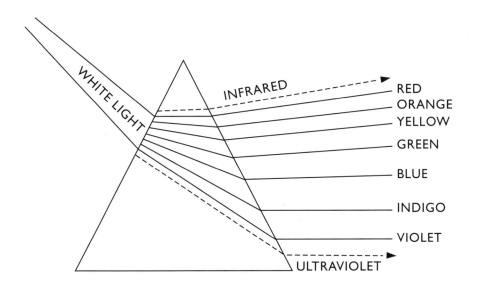

Figure 6–1 *The Component Colors of White Light.*

Newton reported seven distinct colors with his prism: red, orange, yellow, green, blue, indigo (blue-violet), and violet.[57] Many people can't detect indigo as a separate color between blue and violet. One possible explanation for Newton's choice of a seven-hue spectrum of light is that he had unusual visual acuity in the blue-violet range. A more likely explanation is that despite his genius and the intellectual climate around him, Newton was a product of the seventeenth century. Mysticism was a great part of Newton's time. He may have elected to include seven colors because of mystical properties associated with the number seven. Whatever the reason, the seven colors of the physical (light) spectrum persist in recognition of his discovery.

[57] A rainbow is a naturally occurring demonstration of Newton's experiment. Tiny droplets of water in the atmosphere act as tiny prisms, and sunlight is broken into colors.

Newton's contemporaries viewed "Opticks" as a work on the nature of color, not on the nature of light. By the time of his death in 1727, interest in "Opticks" was widespread. The ideas in it generated tremendous controversy all over Europe.

Early in the eighteenth century Jacques Christophe LeBlon, a French printmaker, discovered the primary nature of red, yellow, and blue when mixing pigments for printing. LeBlon's treatise, *Coloritto* (c. 1723) offers the first concept of three primary colors. His work attracted a great deal of attention and acceptance (Birren 1987, page 11) (Hope 1990, page 189). Unlike the Newton's color theories, which concerned light, and Goethe's later ones, which concerned perception and aesthetics, LeBlon's observations are about *the practical reality of mixing dyes and paints*. LeBlon's work is the basis of present-day four-color process printing.

Moses Harris, an English engraver, used LeBlon's three colors to produce the first printed color circle (c. 1766). Harris's color circle, based on multiples of three, was adopted by the seminal color theorist of the nineteenth century, Johann von Wolfgang Goethe.

Goethe was fascinated with color. He was familiar with Newton's theories of color but strongly opposed to them. Goethe bitterly resented the acceptance of Newton's ideas. He wrote, furiously, of Newton: "A great mathematician was possessed with an entirely false notion on the physical origin of color, yet, owing to his great authority as a geometer, the mistakes which he committed as an experimentalist long became sanctioned in the eyes of a world ever fettered in prejudices" (Goethe 1971, page 163).[58]

Goethe viewed colors not as light, but as an entity of their own, as *experienced reality*. His difficulties with Newton's ideas are evident in his own words. Newton's theory, he says, "does not help us to perceive more vividly the world around us" so that "even if we found a basic phenomenon, even then, the problem remains that we would not want to accept it as such" (Lecture 1941, pages 4–5). And, "Things which belong together according to our senses often lose their connections once we look into their causes" (Lecture 1941, page 6).

Goethe also scolded Newton sharply for his views: "The natural philosopher should leave the elementary phenomena in their eternal quietness and pomp" (Lecture 1941, page 5). Goethe is really saying, "Don't fool around with Mother Nature." His response to Newton is pragmatic. In effect Goethe says, "What you say may or may not be true, but it certainly isn't useful in real life."

[58] Goethe spent a great deal of energy trying to prove that Newton was wrong, publishing his first treatise (of a lifelong series intended to refute Newton and his hypotheses), in "*Announcement for a Thesis in Color*" in 1791 (Goethe 1971, page 13).

Like Newton, Goethe was both a genius and a child of the Enlightenment. Unlike Newton, however, he wrote with a sort of shotgun approach, aiming his considerable intellect at a topic, letting fly a lot of ideas, then turning without pause to fire again in a different direction. For today's readers Goethe's writing includes a lot of unintended humor, like the discussion of the color sensibilities of earthworms and butterflies (Goethe 1971, page 250).

Associations of color and beauty with morality were also a part of the Goethe's treatises. There were sinful colors and chaste ones. "People of refinement have a disinclination to colors," declares Goethe, firmly (Goethe 1971, page 261). He associated moral character with not only with choice of colors in clothing, but with skin color as well (Goethe 1971, pages 252–257). [59]

Despite his freewheeling style and digressions, Goethe's observations were wide-ranging and seminal. What we call complementary colors, he calls, with enormous insight, "completing colors" (Goethe 1971, page 55). He reported extensively on the phenomena of simultaneous contrast and afterimage. He recognized that no pure color exists except in theory, and characterized the principal contrasts of color as polarity (contrast or opposition) and gradation (intervals).

Color writers after Goethe expand his ideas and contribute new material and ideas, but Goethe's observations were so wide-ranging and fundamental that almost every concept in modern color study can be found in his work.

Goethe's most familiar contribution to color study is his circular six-hue spectrum of perceived color, based on Moses Harris, which we know as the artists' spectrum: red, orange, yellow, green, blue, and violet. The elegant simplicity of Goethe's spectrum can be described as perfect visual logic, and from this spectrum he hypothesized rules of order, symmetry and balance for harmonious combinations of colors. [60] (*See* Figure C–1 in color insert.)

Goethe's six-hue spectrum remains the convention for artists; Newton's seven-hue model of the full range of visible hues remains the scientist's (physical) spectrum. Probably because the students who pursue sciences are rarely the same ones who go into the visual arts, the differences between the two ideas of the full range of visible hues generally go unnoticed.

The battle over Newton's and Goethe's color theories was a major schism in the history

[59] Sad to say, many of the origins of racism can be found in the writings of early color theorists.

[60] Goethe believed that there were only two primary colors, blue and yellow (Goethe 1971, page 55), and that all colors derived from them. LeBlon's red-yellow-blue primaries prevailed, however, and today we use Goethe's spectrum and LeBlon's three primaries together.

of ideas. It was unnecessary. Both theories are valid, but each describes a different reality:

Newton was looking at causes
Goethe was looking at effects

Figure 6–2 *The Artists' Spectrum.*

Artists and designers deal with effects, not causes. The interactions of light and color are constant, so it's critical that designers understand them. But in the everyday experience of working with color, it is often possible to disregard science. Designers, like Goethe, work with color from the evidence of their senses.

Following Newton and Goethe

Goethe's French contemporary, Michel Eugene Chevreul (1786–1889) addressed color issues from a different viewpoint. Chevreul was faced with a practical problem. As Master of the Gobelin Tapestry Works, he found difficulties with black dyes, which seemed to lose their depth or darkness when placed next to other colors. Chevreul accepted the three-primary-color theory. He observed and reported at length the phenomenon of simultaneous contrast. His 1839 *The Principles of Harmony and Contrast of Colors and Their*

Applications to the Arts (De La Loi du Contraste Simultane des Coleurs) was a profound influence on painters of his time and one of the origins of Impressionism.

Chevreul was an observer and chronicler. Most later color theorists continued to follow the scientific model and codified their observations into systems. The nineteenth- and early twentieth-century color theorists wrote on color as a discipline, as fact, as scientific truth. The stress was on rules, control, and order. Color-order systems became a primary concern.

In *A Grammar of Colors* (1921), American Albert Munsell (1858–1918) devised an ingenious color tree with infinite room for expansion. Munsell colors are organized by hue, value, and chroma (saturation). Each color is assigned a place on an alphanumeric (letter and number) scale. The Munsell system is still used as a teaching tool in many American and British schools today.

Figure 6–3 *Munsell's Color Tree.* This fanciful version illustrates how Munsell imagined color organized in three dimensions.

Figure 6–4 *Color Organization.* Scholarly color-order systems, whether they are two- or three-dimensional, organize color first by hue, then by variations in value and chroma, (saturation). "Tone" in this example indicates grayness.

Although theoretically a complete system, Munsell charts have a fundamental flaw. Saturation is presented as hues, tints, and shades moving in intervals to grays of equal value. There is no place in the Munsell teaching charts for tertiary colors, the chromatic neutrals (mixes of red and green or blue and orange, for example) that are the colors of everyday life. These colors exist as theory in the system, but cannot be demonstrated. The Munsell system also stresses the importance of numbering. Munsell states, "Naturally, every point (of color) has a defined number" so that "there can be no new color discovered for which a place and a symbol is not waiting" (Munsell 1969, page 10).[61]

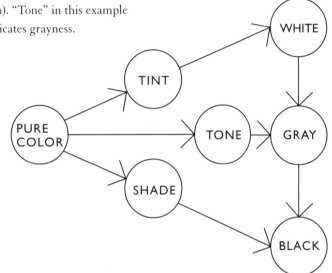

Munsell's teaching is further flawed by distracting associations of colors and morals. Munsell, like Goethe, associated color choices with character and morality. Munsell declares that "Quiet color is a mark of good taste" and "If we wish our children to become well-bred, is it logical to begin by encouraging barbarous (i.e. colorful) tastes?" (Munsell 1969, page 41).

Almost simultaneously, German chemist Wilhelm Ostwald (1853–1932), a Nobel prizewinner, brought a conceptual color solid, originally hypothesized by others, to full-blown theory in *Color Science* (Ostwald 1923, translation 1931). Ostwald's later *The Color Primer*, with an eight-hue spectrum, became mandatory in German schools and in many English ones. It was a strong influence on artists of the Bauhaus movement.

Wilhelm von Bezold (1837–1907) and Ludwig Von Helmholtz (1821–1894) contributed scientific fact to the growing body of color writing. The psychology and physiology of color vision became increasingly interesting to scientists.

By the early twentieth century, color study had become an enormous and wide-ranging topic, positioned uncomfortably with one foot in the sciences and the other in the arts. It remained for the artists and designers of the Bauhaus, a design group founded in 1919 by German architect Walter Gropius, to end its ambiguity.

The Bauhaus group brought the study of color to a level of attention not seen since Goethe's challenge to Newton. Feininger, Klee, Kandinsky, Itten, Albers, and Schlemmer,

[61] Numbering systems are valuable for identifying colors in limited-number color-order systems like paint products or inks. A numbering system is pointless as a tool for learning to *understand* color; there are more than 17 million colors available in software alone.

master-students of color and color theory, addressed color from new directions with intelligence, wit, and energy. Although inevitably some elements of the old (quasi-scientific) style encroached on their writing, they made a definitive break between the study of color as science and the study of color as art and aesthetics. Light remained in the realm of physics; chemistry and engineering took over the nature of colorants; and psychology, physiology, and medicine became the arena for perception.

Johannes Itten (1888–1967) echoes Goethe in defining color as a series of contrast systems and opposing forces.[62] Itten touches upon the earlier tradition as he codifies color harmonies as a sort of geometry, and suggests color chords and formulas for pleasing combinations of colors. But Itten bases his conclusions on the *observation* of color phenomena. He theorizes seven contrasts of color based on perception alone, moving away from the sciences and the more rigid color-order systems. Significantly, Itten's major work is titled *The Art of Color* (1961).

Itten's colleague at the Bauhaus, Josef Albers (1888–1976), made the final break with the color-order tradition. Albers fled Nazi Germany in the early 1930s and brought his teaching methods to Yale. He became the most influential name in color theory in the United States, but his 1963 book *Interaction of Colors* contains no color systems or structures. Albers did not need to contribute to ideas of color order. He had a new role to play.

Josef Albers taught that true understanding of color comes from an *intuitive* approach to studio exercises. He stressed the instability and relativity of perceived colors and the power of visual training. At the same time, he taught that even within this unstable idea of color, effects exist that can be predicted and controlled. [63] In *Interaction of Colors* (1963), Albers casually discounts the benefits of the generations of theory that preceded him. "This book—reverses this order and places practice before theory, which is, after all, the conclusion of practice" (Albers 1963, page 1). For Albers, the visual experience was paramount.

Color-Order Systems and Harmony

Color-order systems were the first concern of the early color theorists because they established a structured field in which they could search for laws of color harmony. Balance and order were thought to be so central to color harmony that hues (and other qualities of color) were frequently associated with laws, numbers, or geometric forms. Goethe repeatedly characterizes color harmony as balance (Goethe 1971). Johannes Itten says that

[62] Itten's contrasts were hue, value (light/dark), saturation (dull/vivid), warmth/coolness, complementary contrast, simultaneous contrast, and contrast of extension (area).

[63] No attempt is made here to list all major writers on color.

"The concept of color harmony should be removed from the realm of subjective attitude into that of objective principle" (Itten 1961, page 19); Ostwald referred to "this basic law—Harmony = Order" (Ostwald 1969, page 65). With his structured charts, Munsell could conclude that "What we call harmonious color is really balance" (Munsell 1969, page 14). There was a complete concurrence of opinion. Balance and order were the rule for harmonious colors.

Two examples are representative of the "mathematical balance" theories of color harmony. Schopenhauer sought perfect balance in a complicated theory of light reflectance, mathematics, the complementary relationship, and relative area. He hypothesized that equal light-reflectance in colors is inherently harmonious. Using Goethe's color circle as a basis, he assigned each hue a number to represent its light-reflecting value in relation to the others (Albers 1963, page 43 and Itten 1961, page 59):[64]

Red	Orange	Yellow	Green	Blue	Violet
6	8	9	6	4	3

The number value of each *pair* of complements totals 12, or a 120-degree arc on the circle. The complementary pairs added together total 36, or 360 degrees, a circle in which each *pair* of complementary colors adds up to an equal arc.

$$
\begin{aligned}
\text{red + green:} \quad & 6 + 6 = 12 \\
\text{blue + orange:} \quad & 4 + 8 = 12 \\
\text{yellow + violet:} \quad & 9 + 3 = 12
\end{aligned}
$$

In Schopenhauer's model, the six pure colors can be represented as a set of 2-inch paper squares. The yellow square is theoretically three times as light-reflecting (or visible) as the violet; the orange twice as luminous as the blue, and red and green equally light-reflecting. In order for the two-inch squares of color to be harmonious, there would have to be three violet squares for each yellow, or two blue for each orange. Using this theory, a shirt with yellow and violet stripes of equal width would be disharmonious. The shirt would be harmonious only if the violet stripes were three times as wide as the yellow ones!

[64] In *The Art of Color* (1961) and again in the *Elements of Color* (1970) Johannes Itten credits Goethe with this number series for light-reflectance in pure colors. This material does not appear in *Goethe's Color Theory* (1971), and Albers credits Schopenhauer with the creation of this theory, even referring to Goethe's "dismay" at the tampering with his color circle (Albers 1963, page 43).

A second mathematically-based concept of harmony is Johannes Itten's theory of color chords, which illustrate harmonies based on variants of complementary contrast. Itten superimposes geometric forms (squares, rectangles, triangles, hexagons) over the artists' spectrum to demonstrate what he called "harmonious chords," calling them "systematic color relationships capable of serving as a basis for composition" (Itten 1961, page 72). Although he describes his chords as dyads, triads, tetrads, and hexads, spelling out each group of colors by name, each is an extension of one idea only: the complementary relationship.

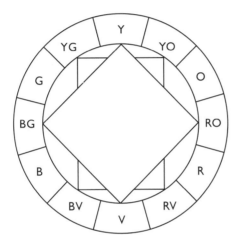

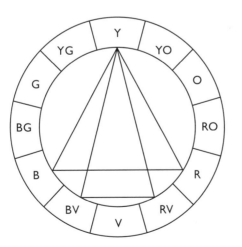

Figure 6–5 *The Harmonious Color Chords of Johannes Itten.* Each of these harmonies has its basis in the complementary relationship.

Color Harmony: A Contemporary View

This century has seen the focus of color study shift from philosophical inquiry to the psychological effects of colors and market-driven research into the sales appeal of colors. Despite this, there's an enduring assumption that those elusive "laws" for pleasing combinations of colors really do exist—and still just await discovery. But in the same way that there are too many colors for each to have a name, there are too many potentially pleasing ways to combine colors for "laws" to be formulated. Imagine that 17 million computer-generated colors were multiplied into all possible harmonious combinations. The number of possibilities is unimaginable.

If the conclusions drawn in the old laws of harmony seem flawed or even ridiculous now, the observations made in establishing those laws remain fresh and valid. Buried in the classical ideas of color harmony are parameters for creating pleasing combinations that transcend historical theories, individual taste, or cultural bias. A colorist can generate an almost endless stream of predictably pleasing, marketable color groupings by working within guidelines that emerge from an idea stated perfectly by Josef Albers: "What counts here—first and last—is not so-called knowledge, but vision—seeing" (Albers 1963, page 2). Albers wasn't first to recognize that the visual experience, not conscious choice, controls the perception of colors as harmonious, but he was the first to assert the primacy of the visual experience over intellectual considerations.

Intervals and Harmony

The nature of human intelligence has been described as the search for order in all things. Babies demonstrate this without words when they place toy rings on a stick in size order. Adults categorize to control information in the same way: large to small, A to Z, and ascending or descending numbers, dates, or sizes. Intervals, particularly even intervals, represent order in perception. Even intervals are easy work for the eyes. Very little effort is needed to discriminate between well-spaced intervals of hue, value, or saturation. The message delivered is steady and uncomplicated. Even intervals don't challenge, disturb, vibrate, or vanish. They are pleasing because they are visually and intellectually *comfortable* (*see* Figure 6–6).

Intervals can be set up between colors of any qualities. Gray-green and bright yellow are an unlikely color combination, but when steps between them are established, a harmonious palette emerges. Establishing a series of intervals is a principal way in which two unrelated colors can be transformed into a harmonious grouping.

A recurring problem in design is creating a pleasing visual link between two or more apparently incompatible colors. You need a sofa and have no money; you have inherited Aunt Maude's buttercup yellow sofa but it will have to sit on your dusty rose rug. Adding pillows in colors that are intervals between the two will produce a harmonious grouping.

Artists have solved the problem of linkage for centuries using a technique called *admixture*. A single color is present, in greater and lesser quantities, in every color in a composition. The resulting wholeness of color is an extension of the idea of analogy. One color is the visual glue that holds all colors together.

Intervals between colors are also the fill-ins for limited palettes, extending the range of colors without disturbing the overall color composition.

The practical applications of this concept extend to all areas of color choice. A green and red design may call for a dark line. Black is a possibility, but it's visually independent of the color scheme and may create a coloring-book type of outline. The mix of red and green, an extremely dark brown, lends a chromatic but still value-contrasting note that has more connection to the red-and-green palette. The neutral background for the red-and-green design can also be a middle mix of the two, diluted to a pale tint. This, too, is more compatible than an arbitrary selection of white or off-white ground.

The resulting sequence of colors still has to play by the rules. It is possible that the new colors must be used as carried colors against a darker or light ground. But no matter how unlikely and incompatible two colors may seem at first, a series of intervals between them will establish a kind of order that the eye accepts as harmonious, and that can be used to create a successful color composition.

Hue and Harmony

Color theorists in general have concentrated ideas of harmony on the relationship between hues. Value as a factor in harmony has been a second consideration, with saturation a

last consideration. [65] The concern with hue has been further focused on the complementary relationship. Hues are also acknowledged to be harmonious when used alone (as monochromatic schemes), or as analogous groupings.

The "menu" of harmonious combinations, therefore, includes single hues (monochromatic schemes), adjacent hues (analogous schemes), opposite hues (complementary schemes), and more complex combinations of these relationships, such as schemes comprised of analogous hues and their complements. The only unstated hue combination is that of two primaries. Common sense tells us that two primaries, like blue and yellow, or yellow and red, can be used together in pleasing ways. When we add "two primaries" to the list, the menu of possible harmonious hue combinations becomes

Any hues used together can be harmonious.

This doesn't mean that any hues used together *are* harmonious. It means only that there are no inherently bad hue combinations.

Complementary colors are used in design so commonly, so consistently, and so successfully, that there must be underlying truth to the idea that complements are harmonious. Red and green, "peach" (orange) and blue, and violet and "gold" (yellow) are recurring (and complementary) combinations. When Goethe called the complements completing colors, he reminded us that complementary pairs contain all three primaries, that the eye seeks equilibrium, and that therefore complementary colors used together fulfill the needs of the eye. Hues in a complementary relationship are physiologically satisfying. Again, "What counts here—first and last—is not so-called knowledge, but vision—seeing" (Albers 1963, page 2). The visual experience supports the classical theories of color harmony. The eye seeks the presence of complementary colors, and therefore we find them pleasing.

A composition of complementary colors used in well-spaced intervals is pleasing on three levels. The eye is satisfied because equilibrium is in place, little effort is required to discriminate between the steps, and the brain's need for order is satisfied.

Analogous colors are (already) intervals between hues. Analogous hues don't satisfy the eye's need for equilibrium, but they, too, are comfortable to the eye because they make perceptual sense. (*See* Figure C–6 in color insert.)

[65] With the exception of Munsell, who also stressed the harmony of middle values.

Value and Harmony

Hue relationships alone are incomplete ideas about color harmony. Although the major role of value contrast is in creating image, traditional color theory states that:

- Even intervals of value are harmonious.
- Middle values are harmonious.
- Equal values in different hues are harmonious.

The most important (and useful) fact about value is that even intervals of value are harmonious. If the same design is rendered twice, once in even intervals of value and once in uneven ones, the design using even intervals will invariably be preferred.

Even intervals of value are easy for the eye to discriminate. At the same time, they meet the human need for order. Intervals of value do not have to extend from the extremes of dark to light to be pleasing. They are harmonious as long as each step is well-distanced from the others: easy to tell apart and easy to see. Intervals that are too close to a viewer's threshold are uncomfortable because they are hard to see.

Figure 6–6 *The Harmony of Even Intervals.* Which design is more appealing?

Munsell declared *middle values* in any hues to be more harmonious than hues at the extremes of light or dark. A middle value is not a necessarily a single color; there is

plenty of dark-to-light range in the middle values. Only the darkest and lightest ends of the scale are excepted.

Middle-value hues are pleasing for a simple reason: they are easy to understand. Viewers select first those colors that can be identified with the least amount of effort. Middle values *alone* cannot be described as "harmonious." A palette limited to middle values, no matter how many hues are included, risks being monotonous.

With this in mind, the statement "*equal* values are harmonious" seems even less promising. A composition with little or no value contrast has no image to excite the eye. Why, then, are these two aspects of value—middle values and equal values—considered harmonious?

To say that "middle values are harmonious" and "equal values are harmonious" is to state two incomplete ideas. The ways in which these colors of equal value are *used* matters a great deal. There are two ways in which hues of close or equal value are used harmoniously. Each depends for its success on the intent of the colorist.

First, hues of middle or equal value are pleasing when they are used as carried colors against a contrasting darker or lighter ground. The design (image or pattern) emerges from the ground with a flat, but richly colored, effect.

A second way in which hues of close or equal value are used with great success is when *no image is intended*. Hues of close or equal value are used together to create lively, complex *surfaces*. Some of the most beautiful stones, ceramic products, book endpapers, textiles, laminates, and wall finishes depend on the interplay of different hues that are close in value. These broken-color surfaces are a form of optical mix. True optical mixes depend on small scale for the eye to fuse several colors into a single new one. Larger areas of color that are close in value meld not into a single new color, but instead create a richly embellished surface on which individual areas of color can be seen, but no image or pattern emerges. These multicolored surfaces are used alone or as the grounds for images or patterns laid over them.

Saturation and Harmony

An argument can be made that muted colors are more "harmonious" than more saturated ones because the eye is at rest in the presence of muted colors. While it is true that bril-

liant colors are exciting to the eye and muted ones are restful, neither is naturally more harmonious than the other. They are different, and are used differently in design. Color harmony is not about the restful or stimulating qualities of single colors. Color harmony is about the collective effect of colors used together. (*See* Figure C–24 in color insert.)

Color compositions are most successful when the level of saturation is relatively constant. When a general level of saturation has been established, any atypical element disrupts the composition. One pure color inserted into a palette of muted ones will pop forward and dominate. It doesn't "belong" to the whole. A muted color appears "grayed," or " dirty," and recedes when it is contrasted with more brilliant colors. A single muted element in a composition of pure colors is a blot in the clean, bright colors around it. (*See* Figure C–27 in color insert.)

Brilliant tints and saturated colors can be introduced into a muted composition to create areas of emphasis. Inserting one or more brilliant colors into a muted composition draws the eye to those colors and separates them—intentionally—from the composition as a whole. Illustrators use intervals of saturation between a pure color and gray to indicate roundness without great depth. The usual way to convey depth in two-dimensional forms is to shade them with dark, which appears to recede, and highlight them with light, which appears to advance. Because brilliant colors appear to advance and muted ones to recede, using intervals of saturation (instead of value) also creates a three-dimensional impression in a softer, less dramatic way. The absence of dark and light keeps the image closer to the surface—less "near and far."

In a floral printed fabric, for example, intervals of saturation from bright green to muted gray-green may be used to suggest leaves receding into gentle shadow. Roses may be illustrated in intervals from brilliant pink to pinkish gray, or from yellow to gray. Complicated textiles, like Aubusson carpets, have dozens of hues, each in many steps of saturation as well as many steps of value.

Well-spaced intervals of saturation used to illustrate depth or dimension in this way do not make brighter colors "pop" out of a composition. A series of graduated steps from bright to gray makes sense to the eye. The saturation level of this kind of composition is a balance between its vivid and muted elements. Colors that have been composed together work together to establish a cumulative, overall level of saturation.

Surface and Harmony

The natural world is a chromatic experience. Although incredibly brilliant colors do exist in nature, the majority of natural colors are muted. The colors of nature are also fragmented. The irregularity of natural materials makes their surface colors more like optical mixes than like flat paint.

A "broken" color, suggesting texture, invites both a tactile response and a visual one. A textured surface—or the illusion of one—engages more of the senses than an area of flat color. Fragmented color is not about hue, value, or saturation. Breaking color to suggest surface movement is a separate idea. It responds to the human need for a connection to the natural world.

Smooth areas of flat color are not unharmonious. They respond to an entirely different human need: a need to control. One example of the use of fragmented color exemplifies how human beings respond to it. Medical facilities often hang images of nature in waiting and treatment areas because they are calming to patients and their families. When medical facility art work is nonrepresentational, the color surfaces are soft-edged and irregular, like natural materials. Hard-edged masses of color are dramatic and compelling: they stimulate rather than soothe the spirit.

Simple and Complex Harmonies

Simple compositions have only a few colors against a ground. Elaborate compositions may have hundreds of colors. Extending the guidelines for simple color harmonies into more complex ones calls for two additional observations.

Successful complex color compositions have a major or dominant hue, often used in an analogous grouping. They may also have a minor, supporting one. A carpet may have dozens of yarns within an analogous blue-green range. Some may be brilliant and others grayed to indicate shading; some may be dark, and some light. The blues and greens together are the major theme; the dominant hue is blue-green. Small quantities of red or red-orange added to the composition create a foil for the blue-greenness. The warm colors support and reinforce the cool ones, emphasizing the blue-green by contrast. (*See* Figure C–25 in color insert.)

Most often a complement or near-complement of the major hue plays the reinforcing, minor role. Color compositions in which two or more hue families compete for equal attention are generally less successful than those with major-minor hue relationships. This observation may be the only view of harmony that is in direct opposition to the old ideas: that perfect balance of the complements is perfect harmony.

There is no way to deny the evidence that a great deal of what we find harmonious is dictated not by conscious choice, but by the involuntary responses of our eyes and minds. Color choices are affected by the need for equilibrium, the comfort level of vision, and logic in perception. We have a built-in bias toward certain combinations.

It's a little disconcerting to think that preferences in color combinations are outside of our control, but it isn't that simple. The eyes dictate boundaries of comfort. The designer's hand and eye create each palette. The designer's *intent* determines whether that palette will be harmonious or disturbing. Not all design problems call for a harmonious palette. Some call for attention-getting color combinations

Visual Impact

The strongest graphic images are created by high value contrast, a visual power that requires no hue. Black and white create the most contrasting, and therefore the most visible images. A second kind of visual power lies in the shock value of certain hues. High-impact colors are both hue-intense and light-reflecting. Used together, they are likely to vibrate, which makes them poor candidates for good "readability." Strong tints of red-violet or saturated yellow-green are examples of high-impact colors. Saturated hues are not necessarily high-impact colors. Pure violet is too dark to compete for attention with many other colors. When a highly visible violet is needed, it is used as a strong tint. (*See* Figure C–26 in color insert.)

High-impact colors are used to draw immediate, short-term attention. They contrast strongly with their surroundings, which makes them valuable in communicating instantly visible, nonverbal warnings. "Dayglo" colors are an extreme of high impact color. The Occupational Safety and Health Administration (OSHA) has mandated high-impact colors for a variety of specific hazards: violet for radiation, for example, or red for fire equipment, or yellow for school buses.

Visual Impact and Area

The size of an area covered by a single color affects how it is perceived. A color selected from a small sample for use on large surfaces undergoes apparent changes in value and chroma.[66] When two or more colors are used to cover areas of *different* sizes in a composition, one color will draw attention away from the other. Itten calls this "contrast of extension" (Itten 1970, page 59). Contrast of extension is about the *relative impact* of colors when they are seen as larger and smaller areas. Albers has a perfect phrase for it: "Quantity is a quality" (Albers 1963, page 43).

No matter what its area, colors will be seen as dominant according to the guidelines of spatial effects.[67] All other factors being equal, a small area of warm color dominates a larger area of cool color; lighter color dominates a larger area of dark, and more saturated or brilliant colors dominate muted ones. Greater or lesser area does not change the impact of colors in relation to to each other. (*See* Figure C–25 in color insert.)

Combinations of colors in which "all factors are equal except one" rarely occur. The dominant quality of a sample—its warmth, high value, or brilliance relative to another color—determines whether it will be understood as the focus of attention. If the walls, floor and seats of an indoor sports arena are carpeted with gray carpet and a rusty red chair is placed in the center, the more hue-intense chair will attract the eye's first attention. If the rusty red chair has a bright yellow handkerchief on it, the more light-reflecting and hue-intense handkerchief will draw the first look.

Dissonance

It's fair to say—as an intellectual argument, anyway—that no color combinations are inherently displeasing. Somewhere, sometime, someone will love a lipstick-red, pea-soup-green, gray-violet and school-bus-yellow dress. On the other hand, it's unlikely that many dresses in this color combination will be sold. Most people would find the colors dissonant. (*See* Figure C–27 in color insert.)

Using dissonant colors is another way to draw attention. Dissonant colorways disturb the eye. They may startle or repel, but they never bore. You may not love the lipstick-red, pea-soup-green, gray-violet, and school-bus-yellow dress, but you won't miss it—and you'll never forget it.

[66] *See* Chapter 5, "Using Color," Color and Area.

[67] *See* Chapter 5, "Using Color," Spatial Effects of Colors.

REFERENCES

Albers, Josef. 1963. *Interaction of Colors*. New Haven: Yale University Press, 1963.

Birren, Faber. *Principles of Color*. West Chester, PA: Schiffer Publishing Company, 1987.

Goethe, Johann von Wolfgang. *Goethe's Color Theory*. Translated by Rupprecht Matthei. New York: Van Nostrand Reinhold Company, 1971.

Goldstein, E. Bruce. *Sensation and Perception*. Belmont, CA: Wadsworth Publishing Company, 1984.

Hope, Augustine and Margaret Walch. *The Color Compendium*. New York: Van Nostrand Reinhold Company, 1990.

Itten, Johannes. *The Art of Color*. Translated by Ernst Van Haagen. New York: Van Nostrand Reinhold, 1960.

Itten, Johannes. *The Elements of Color*. Edited by Faber Birren. Translation by Ernst Van Haagen. New York: Van Nostrand Reinhold, 1970.

Munsell, Albert Henry. *A Grammar of Colors*. New York: Van Nostrand Reinhold, 1969.

Nicolson, Marjorie Hope. *Newton Demands the Muse*. Princeton, NJ: Princeton University Press, 1966.

Ostwald, Wilhelm. *The Color Primer*. New York: Van Nostrand Reinhold, 1969.

Varley, Helen, editor. *COLOR*. New York: The Viking Press Distributors. Los Angeles: The Knapp Press, by Marshall Editions Limited, 1980.

Tools of the Trade

> *Now that we have the machines let us, instead of imitating former products and techniques,*
> *try to design goods that are characteristic of machine production—do not let us imitate*
> *former designs. Let us, with the help of these technical aids, produce the new.*
> —Gregor Paulsson, *Design and Machinery* 1919 [68]

It's the Real Thing

Every product, whether it is a car, a textile, a building, a garment, a printed page, or a
Website, is something that has been *designed*. Individuals or design teams create prototype
products, but the end product—the real thing—is fabricated by others. The creative
phase of the design process ends before goods go into production.

Renderings and models are the essential tools of the design process. Virtually every design
begins as a sketched concept (scribbled on a table napkin, as often as not) that is modified,
revised, and ultimately tweaked into a final image. The final image has a second and equally
important use. Renderings and models are the means of *selling* design. They are the pri-
mary means of communicating a product design, including its color, to a potential buyer.

Perceiving the color of an object is a much more complex visual event than the simple
experience of wavelength. A color is *identified* as red, yellow, or blue, etc., but the whole
experience of an object's color includes subtleties of texture, light-reflectance, and other,
harder-to-define qualities that are characteristic of that particular object and others like it.

Materials like stone, wood, linen, wool, and silk often are used in their natural state
because their inherent colorants are considered pleasing. Most manufactured goods have
color added to make them more appealing to consumers. Products are colored in two
principal ways. Color can be introduced into the substance of the product at the begin-
ning of the manufacturing process, or it can be applied to its surface at some later stage.

[68] Greenhalgh 1993, page 72.

Plastics, solid-vinyl floorings, porcelain tiles and solution-dyed [69] manmade fibers are examples of products whose color is introduced into the base material at an early stage of manufacture. There are limitations to introducing a colorant into any material. The colorant and base material must be chemically compatible, and not all colorants are compatible with all substances. The inclusion of color into the substance of a material offers some advantages—chipping or fading, for example, become lesser problems. But producing a separate base material for each color is costly, so the number of colors available in color-through products is often limited.

Alternatively, color can be applied to the surface of a product at a later stage of production. Applied color typically allows manufacturers to offer a greater number of color choices. Car finishes, glazed ceramic tiles, pottery and china, printed textiles, and printed pages are examples of color applied late in the manufacturing process. Applied colors have their own limitations. Applied color must adhere to the underlying material and perform well in normal use, without chipping, flaking, rubbing off, or bleeding.

A *medium* is "a means, something through which a force is transmitted" (Webster's 1987, page 620). A *design medium* is a means of translating images, ideas, and colors from one kind of visual experience to another. A three-dimensional reality (like a person or object) becomes a two-dimensional image through the medium of paint on paper, or light on a screen. A good design medium transmits the force of a whole visual idea. The best design media enable designers to create images that closely approximate the forms and colors of the actual product.

Every medium conveys color in a slightly different way. Imagine a car that is suddenly available in a new color, a deep blue-green. An artist prepares a color-marker drawing of the car in its new color. The marker drawing is sent to a printer, who scans the image, then prints an advertising brochure. Cars are manufactured, recorded on videotape, and advertised on television. The new color is communicated to viewers through color markers, films, printing inks, videotape, car enamel and television screen—all in an attempt to show a single color idea.

All fields of design share the same challenge: visual thinking and presentation must take place in (at least) one medium for a final production in another. Two very different kinds of media are used in the design studio: one is the traditional media of the artist-designer; the other is the dominant medium of the present-day design studio— the monitor images of digital design.

[69] In solution dyeing a colorant is incorporated into a chemical "soup." The "soup" is forced through a fine nozzle-like device and emerges as long strands of fiber. The fiber is woven into yarn or further processed before being woven.

Artists' Media

Artists' media are substances made up of a liquid, paste, viscous, solid or other inert *base* that contains a colorant. The base and colorant together are the medium. The colorant, a dye or a pigment, selectively absorbs and reflects light.[70] The base is a vehicle (or means) for transferring the colorant from one thing to another. In a good-quality medium the colorant permeates the base evenly and transfers smoothly. There are hundreds of artists' media—among them poster paints, watercolors, oil and acrylic paints, markers, crayons, colored pencils, dyes, and inks.

Dyes are colorants in solution. They are fully dissolved in water, alcohol or some other solvent. Dyes penetrate the material they color and bond with it on the molecular level. Some dyes are translucent, some are opaque. A translucent dye acts as a filter, allowing light to pass through it and reflect back from a white surface below. When light reflects from a white fabric back through a dye, or when a translucent ink is laid on a white paper ground, the effect is light-reflective and brilliant. Before the mid-nineteenth century, most dyes were organic; derived from plant or animal material. Many were "fugitive," oxidizing (fading or changing) rapidly on exposure to light or air.

Pigments are finely ground particles of colorant suspended in a medium. Pigments are typically more opaque and less brilliant than dyes. Pigments "sit" on a surface rather than bonding with it. Traditional pigments were made from ground earths; some were even ground from semiprecious stones. Traditional pigments were, in general, more durable than dyes.

The accidental discovery in 1856 of coal-tar dyes precipitated a quest for ever-more stable and brilliant synthetic colorants. Today's high-performance, space-age synthetic colors have properties and durability unimaginable in the past. Because of their complexity, many of these products bridge the traditional distinctions between dyes and pigments.

Although the colorant alone determines the hue, the base plays a major role in the complete color impression. A base is inert only in the sense that it does not modify light *selectively*. Dyes and pigments are selective. They absorb some wavelengths and reflect others. A base modifies color by absorbing, scattering, or reflecting *general* light. Visual qualities like translucency, opacity, "chalkiness," or "volume," come from the light-modifying qualities of the base.

[70] A colorant can also transmit light. *See* Process Colors, below.

Watercolor and crayon are examples of media whose differences come largely from the modifying quality of the base. Water is a colorless substance that transmits light. It evaporates completely after it is applied, leaving the colorant essentially unmodified. A brilliant dye that is dissolved in water and applied to a white substrate (underlying material), renders colors that are light-reflective, clear and brilliant. Crayon carries the colorant in a wax base. The wax is dense, cloudy, somewhat shiny and slightly translucent. Unlike water, the wax base of a crayon remains after it has been transferred to paper. Wax absorbs a bit of the light reaching it, scatters some light, and allows some light to reach the underlying surface. No matter how brilliant the colorant in a wax crayon, the wax will mute the final color impression to some degree.

Some media have special properties and special uses. "Dayglo" colors, for example, absorb wavelengths of light from above the range of the visible spectrum and re-emit it at a lower range as visible light. The added light-reflectance makes these colors useful for attention-getting purposes—like safety cones on the highway—because they are highly visible against any background.

Subtractive Mixing: Artists' Colors

No medium is available as a complete range of visible hues with all tint, shade, and chroma variations. Instead, each medium is sold as a limited number of colors that can be mixed together to extend its number of colors. A medium may be available in a large number of individual colors, like oil paints or children's crayons, or as a few very similar colors, like natural chalks.

Artist's colors are mixed in a *visually logical* way. Color mixing corresponds to the sequence of the artists' spectrum: two colors are mixed together to produce the color that lies between them.[71] But two artists' colors that are mixed to make a third do not *dependably* produce the expected result. Pure red mixed with pure yellow does not always combine to make orange. In order for mixed colors to produce a new color, they must reflect a wavelength in common. (*See* Figure C–4 in color insert.)

A single medium may have a number of tubes or jars with different names but seemingly identical colors. These colors share the same base, but each contains a different *colorant*. Every colorant reacts differently when mixed with other colors in the same medium.

[71] *See* Chapter 6, "Color Harmony."

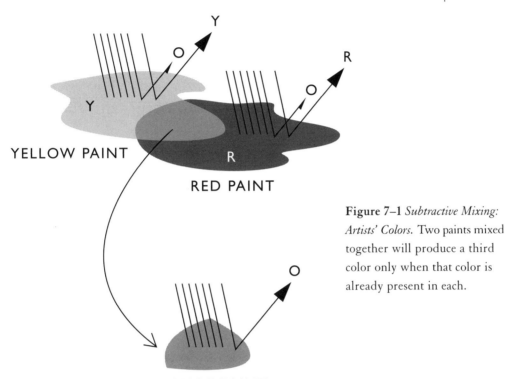

Figure 7–1 *Subtractive Mixing: Artists' Colors.* Two paints mixed together will produce a third color only when that color is already present in each.

Two or more colorants work together to produce a new color in a simple way. Most colorants reflect light of more than one wavelength, although one wavelength is reflected more strongly than others. The dominant wavelength is seen as the color. Weaker wavelengths that are reflected may not be visible to the naked eye.

For example, a certain red paint absorbs yellow, green, blue, indigo, and violet wavelengths. It reflects a strong red wavelength and a weaker orange one. The orange is not apparent to the eye. A certain yellow in the same medium absorbs red, green, blue, indigo, and violet wavelengths. It reflects a strong yellow wavelength and a weaker orange one. Again, the orange is not apparent to the eye.

When the red and yellow paints are mixed, the mixture absorbs all of the colors that each absorbed when used alone (blue, green, indigo. and violet). In addition, the red in the mix now absorbs the yellow wavelength, and the yellow in the mix absorbs the red. The only wavelength that is left to be reflected is orange, the *one wavelength that each of the two mixed paints reflects in common.*

Red and yellow paints chosen *at random* may or may not mix to produce orange. If the two do not reflect a common wavelength, they will mix to make a mud color. No matter how brilliant colors seem when used alone, mixing a red paint (that also reflects violet) with a yellow paint (that also reflects orange) will produce a drab neutral.[72]

Transparent[73] artists' media like watercolors or colored inks are mixed to form new colors in the same way as opaque media, but they have another quality. In addition to selectively absorbing and reflecting wavelengths of light, they allow some light to be transmitted to the paper surface, where it reflects back through the layer of paint or ink. The increased light-reflectance tends to make these media clear and brilliant. Transparency decreases and colors become darker as additional layers of paint or ink are added because less light reaches the paper to be reflected back.

Tinting Strength

Tinting strength refers to the relative *quantity* of a color needed to produce a perceptible difference when mixed into another color. Different hues within the same medium vary in tinting strength.

Most yellows, for example, have little tinting strength. Adding one-half cup of yellow paint to one-half cup of green paint causes little change in the green. But a teaspoon of green added to a cup of yellow changes yellow to yellow-green at once. When colors are mixed, *quantity* does not necessarily produce a predictable result. Only tinting strength matters. Colorants with great tinting strength are like garlic. A teaspoon of garlic in an apple pie will certainly be noticed. On the other hand, a teaspoon of apple in a garlic puree won't make much of an impression.

An experienced colorist makes a selection based on the mixing affinities of specific colors. Predictable mixing is learned by trial and error, from a teacher or fellow student, or from one of the many excellent books on color mixing that have been written for specific media. The skills of color mixing are not the same as the ability to see differences, similarities, and intervals between colors. Each medium has its own set of technical skills, but all media demand the same color discrimination skills.

[72] Kindergarten poster paints are an example of a medium with poor mixing affinities. No two primary colors in poster paints can be mixed to produce a reasonably clear secondary.

[73] "Transparent" media are actually *translucent*. Rather than allowing all light to pass through, which is transparence, they transmit some wavelengths of light through and reflect others. The word "transparence" is used frequently to mean "translucence" in much writing about color. It is used here in that way to avoid conflict with other texts.

Process Colors

Process colors are a medium of the printing and reprographic industries. These colors contain special colorants that are available in a number of different bases such as printing inks, drawing inks, films, and markers. The process colors cyan (blue-green), magenta (red-blue), and yellow are also called *process primaries*.[74]

Process colors are considered to be a subtractive medium, but they are unlike other subtractive media in several important ways. The colors they produce do not result from the selective absorption and reflection of light. Process colors act as filters. Instead of selectively absorbing and *reflecting* wavelengths of light, they absorb some wavelengths of light and *transmit* others. When a process color is laid on white paper, some wavelengths reaching it are absorbed and others are transmitted to the paper surface. The white surface reflects the wavelength (color) reaching it back again through the ink "filter," and it reaches the eye.

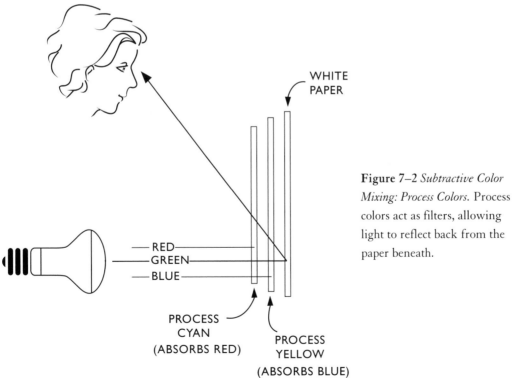

WHITE
PAPER

RED
GREEN
BLUE

PROCESS
CYAN
(ABSORBS RED)

PROCESS
YELLOW
(ABSORBS BLUE)

Figure 7–2 *Subtractive Color Mixing: Process Colors.* Process colors act as filters, allowing light to reflect back from the paper beneath.

[74] These colors are also known as "subtractive primaries," and "subtractive colors." Magenta is also called "process red"; cyan "process blue;" and yellow "process yellow."

The results of mixing process colors do not parallel the mixing of artists' colors *or* the mixing of light. Process-color mixing is unique. Each process color absorbs and transmits specific wavelengths of light: (*See* Figures C–3, C–4 and C–5 in color insert.)

Process magenta absorbs green (and transmits red and blue).
Process yellow absorbs blue (and transmits red and green).
Process cyan absorbs red (and transmits blue and green).

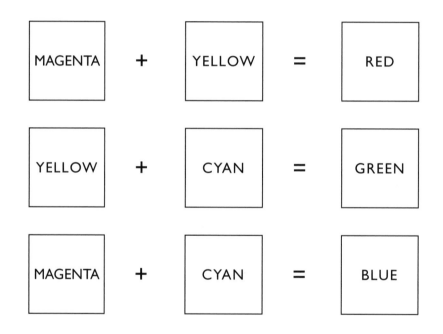

Figure 7–3 *Process Color Mixing.*

When process colors are mixed in equal proportions, they continue to absorb and transmit specific wavelengths:

Magenta and yellow mixed absorb green and blue light (and transmit red); red results.
Yellow and cyan mixed absorb red and blue light (and transmit green); green results.
Magenta and cyan mixed absorb green and red (and transmit blue); blue results.

Process-color, or CMYK (**C**yan, **M**agenta, **Y**ellow and blac**K**) printing is the most familiar and universally used printing process. It is accomplished with the three process colors and black. CMYK printing is used in color xerography, color printers, and most commercial color-press printing.

In CMYK printing, cyan, magenta and yellow are printed as separate steps. Yellow is printed first, followed by magenta, then cyan. Colors are overlaid in different proportions to produce additional hues. The three process colors mixed together produce a medium gray tone, so the addition of black is needed to give sharpness and depth to the color image. The black also works to produce shades and muted colors. The brilliance of a pure color is reduced by adding black in 6% increments (Warren, 1996).

Process colors are available in a great range of artists' media, which makes them useful in the preparation of artwork for printing. A design rendered in process-color markers or inks closely approximates the colors of the printed page. Process colors are not the only kind of printers' ink. Printers also employ solid-color (opaque) inks. Solid-color inks offer greater depth and clarity of hue than process colors, but they do not allow a new color to be produced by overlapping. A solid-color ink prints as a single, opaque color.

Most commercial printing presses are four-color presses that print CMYK colors. Four-color process printing has some shortcomings. It does not produce clear colors in the orange range, many tints do not reproduce well, and gradations of color can be difficult to print (this book is printed in CMYK colors). Although excellent results can be obtained with CMYK colors using special printing presses called eight-color presses, only 300 of these presses are available worldwide. Dealing with the constraints of CMYK color printing is an ongoing challenge for graphic designers.

Pantone, a leader in color-printing inks and related products, has responded to the limitations of CMYK printing with the introduction of a six-color process called Hexachrome®. Hexachrome adds vivid green and bright orange inks to the standard CMYK colors.[75] Printing in Hexachrome requires a six-color printing press, but these presses are reasonably available; more than 7,000 are in use in the United States alone. Most day-to-day color printing, however, including commercial color printing, computer-printer output and color Xerography, is still done in CMYK color with its attendant limitations.[76]

The Computer Medium

Digital design is an umbrella term for design produced on a computer. Digital design programs (software) enable the user to "draw" or "paint" in color on a monitor screen.

[75] In addition to adding two ink colors, Hexachrome colors are enhanced (brighter) and metallic inks are used as brighteners. Hexachrome has its own limitations; flesh tones are difficult to produce.

[76] Pantone, Inc., reprint from October, 1998 edition of *Electronic Publishing*. PennWell, 1998.

Understanding Color

Chapter 7

Because the computer allows a user to generate instantaneous changes in the shape, size, pattern, and distribution of images and colors on the screen, any number of variations of a color idea can be explored without the effort of redrawing or repainting.

A second benefit of digital drawing is that it enables the user to create powerful illusions of three dimensions on the two-dimensional plane of the screen. The perception of three dimensions occurs when the brain receives one or more pieces of visual information called *depth cues*. Software can include such depth cues as shadows, overlap, and perspective, but the most convincing illusions of depth occur when the on-screen image is active. Screen images are transient, fluid, mutable—alive to change. A moving image can include *parallax motion*,[77] a depth cue that cannot exist in static images like a printed page. A digital drawing that has been printed, however, is no more successful in communicating three dimensions than a drawing prepared in any other way.

The time- and labor-saving advantages of digital drawing over traditional rendering techniques translate directly into greater profitability for the design studio. Virtually every design industry relies on the computer to facilitate the design process. Digital drawing is so universal in the design workplace that a crucial difference between digital drawings and those produced by traditional means is often disregarded. *The computer medium is unique because the user draws and paints with light. Only in digital design does the artist render in additive colors objects that will ultimately be experienced as subtractive colors.*

On-Screen Color

Additive color is sensed very differently from color reflected from a "real" surface. "Virtual" reality means *almost* reality. The glass of the screen is always present, interposing a specular surface between the virtual "object" and the eye. Direct light color is very brilliant. Reflected colors are less fatiguing to the eye than additive colors. Reflected light reaching the eye is weaker and more diffused than direct light, because some light energy is lost as light travels from the source to the surface, and more is lost as the light travels from the surface to the eye. Reflected colors also seem more "natural," because human beings are genetically predisposed to understand images seen as reflected color as "real." In nature, general (white) light that comes from an angle 45 degrees above or behind the viewer is sensed as the most "natural." Light emitted by a monitor screen reaches the eye from a direct frontal position.

[77] Parallax motion is the effect that occurs when a moving viewer sees nearby objects as moving rapidly and faraway objects as moving more slowly. A rider on a moving train is unable to read signs that are next to the tracks, but signs at a distance are read with ease.

114

The brilliance of direct light color and the glass can be used to advantage in illustrating certain kinds of surfaces. Additive color and the capabilities of drawing software combine to great effect in the rendering of highly reflective materials. Screen drawings of materials like glass, polished metals, laminates, and high-gloss paints are particularly successful. (*See* Figure C–28 in color insert.)

Materials with a textured or matte surface like unpolished stone, woods, and textiles are more difficult to present on the screen. The monitor screen is a single-sensory medium. Pattern and color can be represented, but conveying the *tactile* quality of materials is not easily done. Textiles are particularly problematic. Textured surfaces both reflect and absorb light. Although color fields on a screen can be fragmented or "broken" into areas of dark and light to suggest texture, the characteristic brilliance and flatness of additive color persist.

A *printed* drawing of a textile that has been prepared digitally is experienced no differently than the same drawing rendered in any other medium. Print on paper is more successful than the screen in conveying the color and surface of a textile, particularly if the image is printed onto a matte or textured paper.

The Color Monitor

Colors on the monitor screen are created by the distribution (pattern) and strength (brightness), of light emitted at different wavelengths. The inside of the monitor screen is coated with phosphors, substances that emit light when bombarded with electrical energy. Each phosphor emits one primary color of light—red, green, or blue—when it is excited by electrical energy at a specific frequency.

A "gun" at the back of the monitor bombards the phosphors with a constantly moving stream of electrical energy at various frequencies. The stream of energy passing rapidly and continuously across the inside of the screen keeps the phosphors glowing. The speed at which the stream passes over the entire screen is the *refresh rate*. The faster the movement of the gun, the faster the refresh rate. A monitor with a slow refresh rate will flicker.

The pixel, or "picture element," is the smallest unit of the screen display. Pixels are measured as dpi, or "dots-per-inch" on the screen. The more dots per inch, the higher the dpi, and the more detail and colors a monitor can display. Each pixel emits light— red, green, blue, or a mixture of these—depending on the frequencies of the electrical impulses reaching it. Mixing the light emission *within* each pixel (mixing red and green light to produce yellow, for example) allows a full range of hues to be displayed.

Individual pixels can be altered in hue, value, and saturation (chroma). The number of ways in which a pixel can be altered (the total number of colors that a monitor can display) is determined by its bit-depth. Black-and-white monitors have a 1-bit depth. Most monitors display colors and shades of gray. The human eye sees 256 levels of dark to light (a gray scale from black to white) as an unbroken gradation. An 8-bit-depth monitor, with 256 possible different combinations of on/off, can display 256 shades of gray (a continuous gradient) and 256 colors, a color range that is adequate for most routine design tasks.

Bit-depth determines only how many colors a monitor is *capable* of displaying. The software determines how many colors are *actually* displayed. The more colors the software has stored as coded information, the more memory the computer needs to store and process that information. Many design undertakings require more than 256 colors. Monitors are available with many display capabilities, including some up to a 36-bit depth that are capable of displaying more than 17 million colors. These use software that requires a tremendous amount of random access memory (RAM).

Monitors come in hundreds of models, each with its own display capabilities. The pattern, strength, and mixtures of the light emitted differs for each manufacturer and model. Some monitors display only a few hundred colors, others, millions of variations. All monitors, however, generate color in the same way. The screen display is experienced as additive color: as light directly to the eye.

Software: Color Display Modes

Programs vary in the ways that they display and mix colors. Generally, the screen displays a basic assortment of hues, a range of grays, and black and white in a box or circle called the *color palette*. The user can mix the colors of the light display in one of three different ways: the CMYK mode, the RGB mode, and the HSV mode. Each kind of display has a limited number of available colors called a *gamut*. Human color vision has a greater range than can be displayed by any of the color gamuts.

The *CMYK* mode of color display imitates the results of mixing process colors. Each color in the CMYK mode represents a color of process ink (cyan, magenta, yellow, black). The CMYK display mode facilitates working on-screen for print production. [78]

A bar display enables the user to select cyan, magenta, yellow, or black as a percentage of the screen display. When two of the CMY colors are mixed without black, clear colors and tints result. Three CMY colors mixed in equal percentages without black make a

[78] Hexachrome software is available for some computer applications. It allows a user to prepare digital artwork ready for commercial printing in Hexachrome colors but does not enable the user to print the six colors using an ordinary/standard computer printer. Hexachrome colors require a six-color printer.

middle gray. Muted colors are achieved by using the gray CMY mix and manipulating one or two colors until the desired effect is achieved.

Gray scales are made by manipulating percentages of black (K) alone. The black is also used for making hues darker: one or two of the CMY colors plus black yields shades. A gray made with black alone (a reduced percentage of black) that is mixed into a pure hue will make it darker, not more muted.[79] Muted colors must be made with the CMY gray mix. Varying the percentages of the three colors enables the designer to display on-screen a full range of colors including most hues, values, and saturations. The CMYK mode requires little new thinking about color mixing for designers who are familiar with process colors.

The *RGB* mode of screen display parallels the behavior of light. Each of the primary colors of light—red, green, and blue—is displayed as a separate bar. The user selects each color for mixing in a range from no display (0%) to full display (100%). When 100% each of the three colors is mixed, the result is white. When none (0%) of each color is mixed, the display is black.

If 50% each of red, green, and blue is displayed, the result is a middle gray. Varying the relative percentages or red, green, and blue in RGB mixtures enables the user to view most hues, values, and saturations. RGB mixing does not correspond to either of the two familiar forms of subtractive mixing, artists' colors or process colors. The RGB mode is the most directly associated with reality of a light medium.

The *HSV* display mode stands for hue, saturation, value. The HSV mode displays a circular color map. Next to the color map are three boxes, one each for hue, value, and saturation. Each box has a range of numerical values. The user first selects a color from the map, then instructs each of the boxes to modify that selection in hue, value or saturation. The HSV mode requires learning to mix color in a way that is associated only with digital design. Unlike the CMYK or RGB modes, it does not correspond to either additive or subtractive color mixing.[80]

Output: Printed Images

Screen images can be saved at any point in the design process. They can be saved in the computer memory, saved on disks or on CDs, printed, or saved in all of these ways. In the simplest scenario, the screen image is merely a step leading to a printed page. When a screen drawing is printed directly onto paper using a color printer, the computer is in use as a *drawing instrument*, but the *medium* is printing ink.

[79] Note the difference in mixing colors between a CMYK light display and CMYK inks. In mixing inks, black is used to produce both shades and muted colors (*See* Process Colors, above).

[80] Software for the HSV display mode is also marketed under different names: HSL (hue, saturation, lightness) and HSB (hue, saturation, brightness).

Color printers produce continuous fields and shadings of color using CMYK inks. The printer separates the digital image into four bitmaps, one each for cyan, magenta, yellow, and black. Each bitmap duplicates the number and pattern of pixels of that color in the digital image. The bitmaps are printed out as dots, overlaid in different densities, and positioned at different angles. Printers vary widely in performance (and cost), but a high-quality color printer produces a reasonably good color page within the limitations of the CMYK process.

Tools are available that reduce the difficulties of making the transition from screen color to printed color. *Calibrating* the monitor is the first step. To calibrate a monitor means to adjust it so that specific combinations of red, green, and blue signals produce specific colors on-screen. The standardized colors can be compared with a set of equally standardized print colors, so the on-screen image is a reasonably accurate prediction of how colors will appear on the printed page.

A monitor that is used for design purposes must be calibrated on a regular basis. A number of color-management (software) programs are available for purposes of calibration, but calibration is pointless unless screen colors can be compared to printed colors on paper. A physical set of standardized printed colors is needed for reference and comparison.

Calibrating the monitor and comparing its colors to a set of printed standards is effective only when matching screen colors to print colors. In order for screen colors to approximate the color of an actual product, the source of the image must also be standardized. This means that the color of the product and any photograph, transparency, scanned image, or rendering of it must also conform to the same set of standards. Unless all of these elements can be cross-referenced to the same standards, even the most carefully prepared screen image is potentially unreliable as an indicator of product color.

Not all printed images produced digitally are created by a user mixing colors. A scanner takes art work (a photographic transparency or a piece of opaque art) and, using a special light source (5200 Kelvin lamp) separates the colors into three electrical impulses, one each for red, green, and blue . Each electrical impulse is relative in strength to the quantity of that reflected color in the art. The electrical impulses, which are analog (continuous) information, are translated by the scanner into digital information (pixels) and from additive color—red, green, blue—into CMYK for printing onto paper. Digital cameras

transmit photographic images directly onto the computer hard drive, where they can be retrieved, modified, and printed or saved on the hard drive, on floppy disks or on CDs.

When a digital drawing is printed, the disparity between the real object and the design rendering is no different than if the drawing were done using traditional media like pen, pencil, or marker. A printed image that began as a digital drawing is experienced in exactly the same way as a printed image created in any other way.

Printed colors cannot be matched exactly to colors on-screen. It is not possible to "match" additive and subtractive colors. As with any matching problem, the best that a designer can hope to achieve between screen and printed page is an acceptable match—one that suggests the same color in a convincing way. The critical factor in matching is, as always, the color-discrimination skill of the designer's eye. The ultimate decision on the quality of a "match" is made by the user, not by the software.

Output: Distributed Screen Images

No matter what mode is used to mix colors on screen, the range of colors that can be printed is restricted to the capabilities of the printing process—solid-color, four- or six-color process, or other. A user seeking a different audience can elect not to print at all. A screen image itself can be the design rendering. The image can be saved on disks or CDS for circulation to individuals or groups for viewing on their own monitors, or for distribution on the Internet. Screen images are an alternative to the printed page.

Skipping the print phase of product presentation makes full use of the computer as a *medium*. Programs, particularly RGB programs, are capable of displaying a greater range of colors on-screen than can easily be printed. High-quality monitors using powerful software can display millions of colors. Screen images are potentially richer in their color than any other medium of visual communication, but the constraints of the additive medium persist when a designer must communicate the colors of real objects.

Screen renderings that are distributed for viewing on different monitors have an additional limitation. In order for all viewers to see the same colors, their monitors must be calibrated in the same way—standardized with each other as well as with the source of the color image. Monitors that share the same display capabilities can be calibrated

identically so that a number of monitors will display the same colors with a high level of consistency. Monitors that have different display capabilities cannot be calibrated in precisely the same way, but they can be calibrated to the same set of standards, so that a good level of display consistency can be achieved.

Website Colors

Website design is graphic design that is executed entirely in light. The problem of translating subtractive color into additive color does not exist: both the design medium and the product are additive color. More than that, the design medium and the product are the same entity. Designing a Website is, theoretically, a perfect marriage of means and end.

Viewing a Website shares the color-reception issues of any distributed screen image. Since screen colors depend on the display properties of the receiving monitor, there is no guarantee that the site designer's colors and their relationships to each other will reach the audience with any fidelity. Consumers—the great Web audience—are unlikely to calibrate monitors or to use color references. Even those who do so will not necessarily employ the same calibration and set of standards. Realistically, the colors of a Website will vary on each screen it reaches.

The Internet is *reading* material—words and images. The only difference between designing for print and designing a Website is that the Website designer may want to avoid subtleties of color that may—or may not—reach viewers as the designer intended them. Beyond that single constraint, good graphic design is prepared in the same way whether it is to be executed in printing inks or in light.

Purchasing Color Online

Color is the single most important factor in making a decision to purchase—60% of the decision to buy is based on color (Rodemann 1999, page 170). Apparel and home furnishings represent a major segment of Internet sales offerings, and textiles may well be the most difficult images to convey in additive color. Closing the gap between screen color and product color is an ongoing challenge for Internet vendors and shoppers. No perfect solution exists, but a number of strategies, both high- and low-tech, have been devised to address it.

A representative high-tech response is called True Internet Color. When a user goes to a site that has licensed True Internet Color (or to the Website of its developer, E-Color), information about how the consumer's monitor receives color is recorded. The user must download software from the site and respond to some questions. Once the user has downloaded the software, each time that monitor visits a site that uses True Internet Color, the site will recognize the monitor and adjust its color to "match" that of the online product.

Pantone has devised a more pragmatic approach to Internet selling. The Pantone system recognizes that printed samples communicate the colors of objects more successfully than images of light. Manufacturers and retailers of apparel and home furnishings who choose this system must coordinate their product colors with a PANTONE® color system for textiles. Participating Internet vendors are provided with printed color samples, similar in format to paint charts, that illustrate the standardized set of numbered colors. Vendors distribute the paper samples to consumers, who view potential purchases on-screen, then confirm color choices by referring to the numbered paper samples. Pantone characterizes this non-technological approach as a "shop-by-color" strategy rather than a "better color-viewing" strategy.[81]

It makes little difference at this time whether purchasers opt for high-tech or low-tech aids in choosing the colors of Internet purchases. Either strategy requires a high level of coordination between manufacturer, vendor, and consumer. Even if large manufacturers and vendors were to adopt a standardized color-referencing system, and were able to persuade consumers to participate, the countless small, independent vendors who populate the Internet seem unlikely as participants. The freewheeling nature of e-commerce may be a natural barrier to general acceptance of the color-purchasing aids that are currently available.

Selecting a Medium

The difficulties inherent in displaying additive colors as representations of subtractive colors are widely acknowledged in the design professions. The most successful efforts to manage them have been made in the printing industry, where the CMYK process colors already in general use are the standards for design software.[82] The coordination between process ink colors and graphic design program colors is good, but the issue is not perfectly resolved. At the time of this writing, a user looking for an acceptable match between a screen color and a product color, including the colors of a printed page, must still use a separate,

[81] *"Getting Colors Right with the New Technology"* by Catherine Greenman, *The New York Times*, February 10, 2000.

[82] *See* also Hexachrome®, above.

physical reference, such as a printed sample, textile, plastic, or other real material, as a standard for screen colors.

The color industry's current focus on "matching" colors of light to the colors of objects is a response to demand from all levels of the consumer economy. Designers need to work with digital images that correspond in color to real-world materials. Internet sales depend on effective color presentation. Consumers want reassurance that the colors of products they order are the colors they will receive. The solutions that are currently available for "matching" product colors to screen colors are based on a questionable assumption: that designers, manufacturers and vendors of consumer products, as well as consumers, will accept a universal and standardized palette.

It is unlikely that the essential nature of the screen image as *light* will change. It seems very likely, however, that future color imaging will be capable of producing a visual experience that more effectively conveys the subtractive world we are genetically programmed to understand as real. More "natural" appearing screen colors, even holographic images in color will be possible. Other senses will be addressed—touch, smell, taste—to reinforce the sense of object reality. That it will be possible to create an "experience" of subtractive color on-screen is no more improbable than the three-dimensional "experiences" that we already take for granted.

In an imaginary world where everyone sees color in exactly the same way, a perfect medium for illustrating colors would exist. In a perfect book on color, the illustrations would use this perfect medium. Students would use it for color exercises, then use it later in their various professions. In the real world there is no universal or perfect medium. A professional selects a rendering medium for its ease of use and ability to communicate the image and colors of the end product. Selecting a medium means making compromises between what a medium can do—and what it cannot.

REFERENCES

Birren, Faber. *Color Perception in Art*. New York: Van Nostrand Reinhold, 1976.
Cotton, Bob and Richard Oliver. *The Cyberspace Lexicon*. London: Phaidon, 1994.
Crofton, Ian. *A Dictionary of Art*. London: Routledge, 1988.
Greenhalgh, Paul. *Quotations and Sources on Design and the Decorative Arts*. Manchester: Manchester Press, distributed by St. Martin's Press, 1993.

Holtzschue, Linda and Edward Noriega. *Design Fundamental for the Digital Age*. New York: Van Nostrand Reinhold Company, 1997.

Hope, Augustine and Margaret Walch. *The Color Compendium*. New York: Van Nostrand Reinhold Company, 1990.

Itten, Johannes. *The Art of Color*. Translated by Ernst Van Haagen. New York: Van Nostrand Reinhold, 1960.

Light and Color. General Electric Publication TO–119, 1978.

Pantone, Inc., reprint from October, 1998 edition of *Electronic Publishing*. PennWell, 1998.

Rodemann, Patricia A. *Patterns in Interior Environments: Perception, Psychology and Practice*. New York. John Wiley & Sons, Inc., 1999.

Sappi, Warren. *The Warren Standard Volume Three No. Two*. SD Warren Company, 225 Franklin Street Boston, MA 02110 #96–5626 ©1996.

The New Lexicon Webster's Dictionary of the English Language. New York: Lexicon Publications, 1987.

Vince, John. *The Language of Computer Graphics*. London: Architecture Design and Technology Press, 1990.

The Business of Color

Palettes and Color Cycles / Color Forecasting / Traditional Colors /
Color and Product Identity / Influences on Palettes

Color is the largest single factor in a consumer's decision of whether or not to make a purchase. Market research indicates that 90% of consumer purchases are the result of a deliberate search—and that only 10% of purchases are made on impulse. And of those planned purchases, 60% of the decision to buy involves color (Rodemann 1999, page 170).

A consumer economy relies on a constant demand for the *new*—including new colors. This demand originates at both ends of the market: consumers want a fresh look, and industries make a deliberate effort to step up sales by offering goods in new colors. Manufacturers depend for their survival (or at least for their profitability) on being able to anticipate which new colors will be preferred by the purchasing public. And while this has always been true for the makers of short sales-life products like cosmetics or apparel, it is now true for all consumer goods. Today, even computers come in "fashion" colors. The manufacturer whose colors meet current tastes has a powerful competitive edge.

Palettes and Color Cycles

A palette is a specific group of colors that is characteristic of something—a culture, an artist, a time period. Palettes shift in response to outside forces like developing technology, exposure to new cultures, politics, and fashions. *Color cycles* are stages in the continually shifting consumer preference for certain palettes. A color cycle represents a prevalence of certain colors in the context of a particular time.[83] The candy pastels of Miami Beach are typical of Art Deco design. The muted colors of natural dyes characterize the textiles of the late-nineteenth-century anti-Industrial-Revolution designer William Morris. Structural panels of salmon and turquoise remind us of the 1950s. The "psychedelic" colors of the 1960s have as a subtext, for better or worse, a belief in "better living through chemistry." (*See* Figure C–24 in color insert.)

Tracking the rise and fall of color cycles is a twentieth-century phenomenon. At the outbreak of World War I in 1914, American manufacturers of women's apparel textiles became aware that they would not have access to the fashion colors dictated by Paris, at that time the fashion capital of the world. The Textile Color Card Association of America was formed and, within a short time, produced a first book of samples called *The Standard*

[83] The linking of colors to historical periods can provide important clues to the age of objects. Navajo blankets and Japanese prints are dated in part by their colors; aniline dyes reached both the southwestern United States and Japan late in the nineteenth century.

Color Reference of America. This palette of 106 colors, dyed on silk ribbons, was meant specifically as a color marketing reference for the women's apparel textile industry. The colors were inspired by nature, by university colors, and the colors of Armed Forces uniforms (Linton 1994, page ix).

The number of colors in the *Standard Reference* grew steadily over time. Colors initiated by the apparel industry trickled down to home furnishings and, later still, to hard goods like appliances and automobiles. The demand for new colors created by color stylists at the top of the pyramid forced obsolescence of older goods. By the mid-twentieth century, average color cycles were seven years or slightly longer, coinciding roughly with the decades. Fashion colors preceded other industries by about two years. Cycles tended to repeat in a fairly predictable fashion, from brilliant, full-saturation, colors to more muted ones, to neutral palettes, then back again to strong hues. (*See* Figure C–29 in color insert.)

The women's apparel industry remained the focus of interest until the end of World War II, when other consumer-oriented industries became sensitive to the marketing power and manufacturing advantages of a controlled palette. The Color Association of the United States (CAUS), an outgrowth of the Textile Color Card Association of America, began to publish palettes for other industries: manmade fibers in the1950s, menswear in the 1960s, home furnishing in the 1970s, and, in the 1980s, international and environmental colors.

As color increasingly became recognized as a force in marketing, other industries seized the initiative in originating palettes. The apparel industry lost its place as the sole arbiter of fashionable colors. It is no longer possible to isolate a single industry as the originator of color trends, nor is the length of a color cycle dependable. Color influences have "gone global." Consumer preferences arise from a multitude of sources such as pop culture, movies, museum shows, travel, and Internet communications, as well as from new directions in technology and industry. These influences initiate the trends that precede each new color cycle. Cycles are also shorter and more transient. Color cycles for clothing are now estimated at two years and colors for home furnishings and interiors for approximately seven years.

Color Forecasting

Manufacturers want to know as much as possible about likely new consumer color preferences before they begin production of new goods. Nowhere do psychology and

marketing interact more closely than in the area of consumer color preferences. Hundreds of organizations and individuals, both nonprofit and for-profit, provide (among other services) research on color and prediction of incoming color trends for target markets and target industries. These individuals and organizations provide an increasingly vital service called *color forecasting*.

Manufacturers and vendors rely on color forecasting to enhance their ability to compete for the consumer dollar. Color professionals provide information and guidance on the next wave of color demand; consulting on everything from hair colors and flowers to appliances and buildings. Organizations like the Color Marketing Group (CMG) and Color Association of the United States (CAUS) identify and predict color trends through a wide variety of indicators: observation and reporting by individual members, meetings and workshops, and by scientific consumer testing, consumer surveys, and by analyzing how consumers respond to a number of cultural forces. Regional factors are also considered, because not all colors sell in all climates.

Color forecasts are made for both short and long term—for periods of one to three years, depending on the industry served. New palettes are arrived at by a consensus of members who meet on a regular basis to report their observations on "movement" in current colors—"toward a greener yellow," for example, as well as incoming and outgoing colors. The resulting palettes, which are published several times a year, reflect the focus of incoming trends.

Color forecasting has its limitations. Color forecasting must reflect public taste and direct it at the same time. People cannot be forced to like, or to buy, new colors. Typically, individual consumers do not adopt all the colors in a new palette. New colors and color combinations are successful only when they can easily be integrated into existing color schemes. In home furnishings, only new households have the luxury of a wholly new color scheme (Rodemann 1999, page 171). The same is true for apparel. People do not discard all of their clothing from a previous season. Color cycles are not so much abrupt changes as they are movements from one palette into another.

The advantage to manufacturers of "forecast" colors is obvious: advance information about future consumer color preferences means increased sales. The motto of the CMG is "Color sells...and the right colors sell better!" is followed by "CMG: Forecasting the Color of Profit."

Color forecasting offers benefits to the consumer as well. When the fashion industry works within a similar seasonal palette, time-pressed shoppers find it easier to coordinate suits, ties, blouses, skirts and cosmetics. When home-furnishings products are available in related colors, it is easy for the consumer to purchase compatible carpets, paints, wallpapers, building products, bed linens, china, and the multitude of other items that make a home.

Although color forecasting began in the United States, it is no longer an exclusively American industry. International color groups are active, holding annual fairs. Each year a European "Hall of Prediction" is held in Paris. London has its Colour Group, a panel with representatives from a variety of industries including paint, plastics, and automobiles.[84]

Traditional Colors

Trends are only one consideration in color marketing. Consumers are a complicated crowd; varying by age, gender, income, education, social status, cultural background and geography. Target markets exist for everything, including those for colors. No matter how successful current fashion colors may be, consumers at all economic levels will continue to demand products in "traditional" colorings. Although traditional colors exist for some items of apparel—bridal wear and hunting gear are good examples—the market for traditional or "period" colors is particularly strong in the home furnishings industries.

Reproduced "period" colors have not always been historically accurate, and they are not all accurate today. Nearly all colors oxidize (change after exposure to air and light) over time. Years of accumulated grime mute even the most durable colorants, and current levels of air pollution accelerate the destructive process. Not only are colors altered by soiling and oxidizing, the various colors in a composition alter at different rates. In a single textile or painted object, some colors change enormously over time and others hardly at all, so the original balance of the palette is lost.[85]

Many consumers identify the muted quality of faded textiles and paints as antique. These colors are *marketed* as traditional colorings because they are what is expected. Sophisticated techniques of analysis now make it possible for the original colors of paintings, textiles, and decorative objects to be determined with greater accuracy. New methods of cleaning uncover close-to-original hues. Textiles and paints are available as facsimiles of the

[84] Jack Lenor Larsen has noted that "because color forecasting works (it is, after all, self-fulfilling) we shall see more of it but it will, necessarily, be more focused." (Linton 1994, page x).

[85] A few ancient colorings survive nearly intact. The tomb paintings of the Egyptians, rendered in durable earth pigments, were protected for thousands of years by the dry air of the desert and the protected sites of the tombs. Many Medieval illuminated manuscripts survive in astonishingly beautiful condition, in part because of the durability of the colorants and in part because they were protected as religious objects.

antique colors, colored as they were when they were new, not in their faded state. The reproductions are *document* (historically accurate) colors. (*See* Figures C–24 and C–27 in color insert.)

Current research and restoration techniques have caused a small revolution in historic preservation. Building restoration, both interior and exterior, has taken on a new and controversial face as color accuracy supersedes the old conventions. When the Rose Room in the White House was refurbished during the Kennedy administration, there was a furor over the brilliance of the red-violet walls. The restored color was as it had been originally, but it was shocking to a public used to thinking of "period" colors as subdued.

Color and Product Identity

A separate goal of color marketing is the attempt to establish a link in the consumer's mind between a certain color and a specific product. IBM is Big Blue; Coca Cola has its signature red, and McDonald's arches are dependably golden. But color is always a secondary identifier. *A color has no identity without form.* No matter how familiar a color may be, it is impossible to interpret color alone as an object, situation, or even a symbol, unless it is accompanied by a familiar form or arrangement of forms. Color becomes the leading visual cue to product identity only when a form is so generic that additional information is necessary for recognition. The Tiffany box is any old box—except for its distinctive blue color.

Color and form *together* can be entirely successful in establishing a color-product link. The safe, dependable scissors are orange.[86] The chocolate-brown wrapper tells us that we are about to bite into a Hershey bar, not a Nestle's bar (which has a "dairy" theme, and blue-and-white wrapper).[87]

Influences on Palettes

New technologies—the *ability* to produce new colors—are among the strongest influences on palettes. Early man had only the tetrachrome palette (the red and yellow ochres, vine charcoal, and chalk still used by aboriginal cultures). The Egyptians, Minoans, Greeks, and Romans expanded the number of colorants in use until, by the Middle Ages, there was an enormous range of colors available for all of the arts—textiles, wall paintings, glass, ceramics, book illumination, and metals.

[86] The scissors made by Fiskars, Inc. were originally made in "safety orange" to emphasize their safety, not as a color identifier. They became so recognizable that Fiskars has kept the color.

[87] Only very young children differentiate between similar visual experiences by color, a process called color-dominance. A small child shown a blue cow, a red cow, and a blue horse will identify the blue horse and cow as the same and the red cow as different. Between the ages of three and six, the primary mechanism for differentiating between similar visual experiences shifts to selection by form and configuration of forms, call form-dominance. Adults identify visual situations using form-dominance. No color can be understood alone as an object, situation, or even a symbol, unless it is accompanied by a form or arrangement of forms (Sharpe, 1975). The designer of the Dove chocolate bar, recognizing this, created a whole new chocolate bar form.

Sources for colors were natural: earths and organic colors like lapis, copper, red from iron, cobalt blue, antimony yellow, lime vermilion from cinnabar (sulfide of mercury, the prized and brightest red of the ancient world), and green from malachite. Other colorants were animal or vegetable: murex purple from shellfish, red from madder, yellow from saffron, and blue from woad. The Renaissance saw the replacement of murex purple, a shellfish-based dye, by cochineal, which was more stable.

Until the late nineteenth century, the use of locally available materials and technologies to create colors meant that certain palettes typified specific cultures and places. Many colors and color combinations had an ethnic identity. Returning travelers, soldiers, and explorers added these colors to the Western color canon. The early Crusaders brought turquoise to Europe from the Near East; the Portugese brought indigo from India. The expansion of Western influence into Africa and the Near and Far East in the nineteenth century saw an unparalleled—and two-way—exchange of color influences. Palettes remained typical of cultures but were not confined to them. But the most significant change since prehistory in the ability to create colors came about by accident.

In 1856, an 18-year-old English chemist's assistant named William Henry Perkin was attempting to formulate synthetic quinine from coal tars when he noticed that his rags were stained a deep purple. Perkin had stumbled upon coal tar dyes. Perkin's first color, "mauvine," or aniline purple, was followed quickly by additional colors. His discovery of aniline dyes was so well received that he was able to retire at thirty-five, a rich man.

Perkin's accidental discovery of aniline dyes laid the groundwork for today's synthetic colorants. Although the first aniline colors were followed briefly by a return to natural dyes, the rapidly expanding array of synthetics quickly took over. Synthetic colorants are the norm in today's commercial market. In fact, natural dyes are so rarely used that they are found almost entirely in luxury handcraft goods, like Oriental carpets and Harris tweeds, and in some historic reproduction items. Chemistry, not nature, will dictate the colors of the new millennium

Technology is only one influence on palettes. Political, cultural, and social events are traditionally instrumental in bringing new colors and combinations to the public eye. When Worth, the Parisian designer to the Empress Josephine, began to design for the English aristocracy as well as the French, French colors crossed the English Channel— and then the Atlantic. Colors in the second decade of the twentieth century felt the impact of Diaghlev's dazzling costumes for the Ballets Russe in Paris (1909), while artist-designers

Leon Bakst, Robert and Sonia Delaunay and Matisse also infused brilliant color into the palette of the early century.

When World War I ended the primacy of the French in dictating fashion colors, the inspiration for fashion colors came from America: the glamor of Hollywood and America's growing industrial might created a palette of silver, black, and white. The Great Depression of the 1930s brought browns, drabs, and colors associated with warmth and comfort. Art exhibitions inspired new palettes: a 1935 Van Gogh exhibition in the United States created a vogue for sunflower prints in browns, greens, and yellows. During the World War II, facilities turned to war production, and patriotic colors were the norm.

Today, the globalization of commerce has blurred the lines between colors that could once be identified as representative of certain cultures and times. Typically Japanese combinations are now as common in Milan as in Tokyo. "Retro" colors have their own audience. No single source inspires the colors of fashion or industry. There have never been richer or more varied sources of inspiration available to colorists, and there has never been a larger or more varied audience for those colors. In the free-wheeling climate of twentieth-century design, any combination is desirable, any combination is acceptable.

Colorists are blessed with this multitude of sources, but they're also faced with conflicting demands. The market appeal of colors is crucial to sales, and therefore to the design process. Colorists who compete in the global marketplace must provide innovative colorings, up-to-the-minute fashion colorings, and classic, timeless colorings of equal marketability. Creating palettes for the consumer economy is a delicate balance between design and commerce.

References

Hope, Augustine and Margaret Walch. *The Color Compendium*. New York: Van Nostrand Reinhold Company, 1990.

Linton, Harold. *Color Forecasting—A Survey of International Color Marketing*. New York: Van Nostrand Reinhold, 1994.

Rodemann, Patricia A. *Patterns in Interior Environments: Perception, Psychology and Practice*. New York. John Wiley & Sons, Inc., 1999.

Sharpe, Deborah. *The Psychology of Color and Design*. Totowa, NJ: Littlefield, Adams and Company, 1975.

Varley, Helen, editor. *COLOR*. New York: The Viking Press Distributors. Los Angeles: The Knapp Press, by Marshall Editions Limited, 1980.

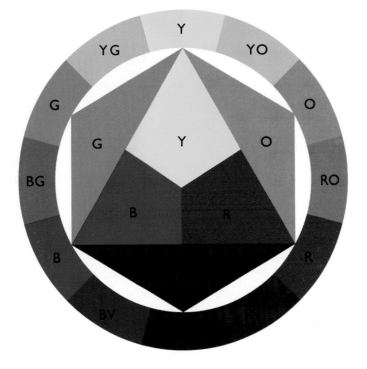

Figure C–1 *The Artists' Spectrum.*

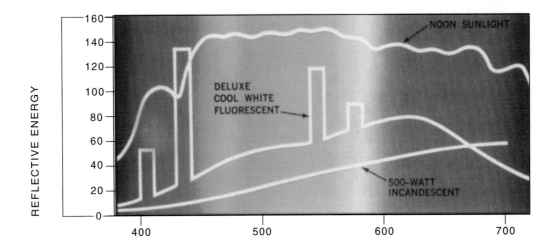

Figure C–2 *The Visible Wavelengths of Light.* Each light source emits the various wavelengths at different levels of energy. The white light that results will vary in warmth (red, orange, or yellow dominance) or coolness (green, blue, or violet dominance) in relation to the amount of energy emitted in that range. Courtesy of General Electric.

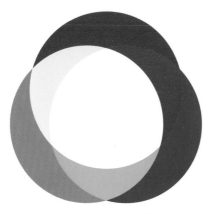

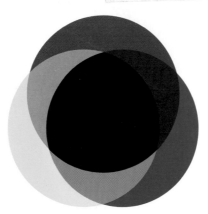

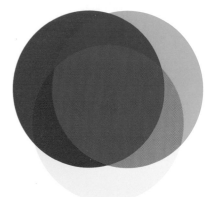

Figure C–3 *Additive Color Mixing*. The light primaries—red, green, and blue—are mixed to form the secondaries—cyan, magenta, and yellow. All three mixed result in white light.

Figure C–4 *Subtractive Color Mixing*. The artists' primaries—red, blue, and yellow—are mixed to form the secondaries—orange, green, and violet. All three mixed result in near-black.

Figure C–5 *Process Color Mixing*. The process primaries—cyan, magenta, and yellow—are mixed to form the secondaries—red, blue, and green. All three mixed result in a dull, dark gray.

Figure C–6 *Analogous Hues*. Analogy is a relationship between hues no matter what their saturation or value.

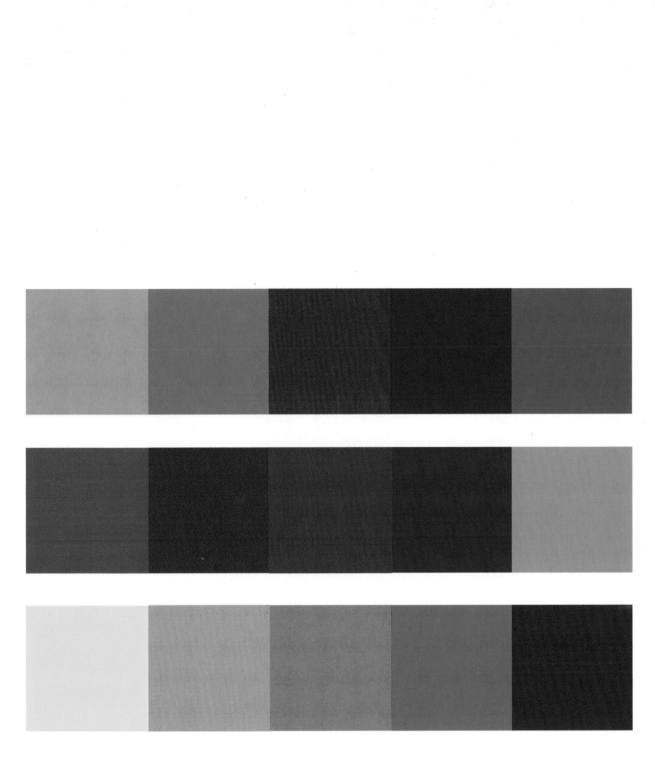

Figure C–7 *Complementary Colors*. Adding a small amount of its complement to a pure color reduces its chroma (saturation) and changes its value. Tertiary colors are chromatic neutrals that cannot be identified as any definite hue.

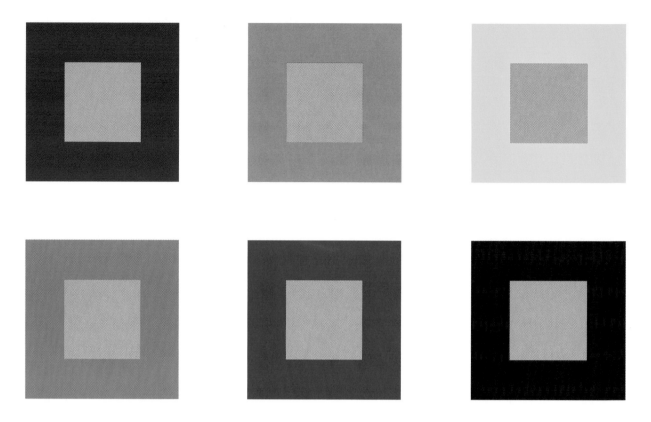

Figure C–8 *Simultaneous Contrast*. Study the gray in the center of one pair of complements at a time. What differences do you see?

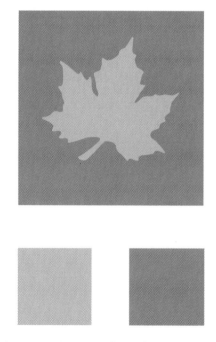

Figure C–9 *Complementary Contrast*. When colors with even a suggestion of a complementary relationship are used together, their hue differences are emphasized.

Figure C–10 *Hue and Image*. The butterflies are different hues, but their value placements are identical. They are different versions of the same butterfly. (*See* Figure 4-6 for comparison.)

Figure C–11 *Hues of Equal Value.* The six spectrum colors in the same value.

Figure C–12 *A Monochromatic Value Scale: Yellow.*

Figure C–13 *Saturation.* Hue and value can remain the same even when saturation changes. One half the tile design is clear and brilliant; the other half is dull.

Figure C–14 *Pure Hues Diluted by Gray of Equal Value.*

Figure C–15 *White Adds Sparkle When Hues Are Close in Value.*

Figure C–16 *Vibration.* Brilliant, unlike hues of equal value cause vibration. The effect is eliminated by the insertion of a value-contrasting line.

Figure C–17 *Vanishing Boundaries.* Two similar hues of the same value lose their edges when placed next to each other.

Figure C–18 *Transparence Illusion.*

Figure C–19 *Spatial Effects of Colors.* Warm colors advance in relation to cool colors, and vivid colors advance in relation to muted ones.

Figure C–20 *Ground subtraction: One Color as Two.*

Figure C–21 *How Many Colors Are Actually Printed?*

Figure C–22 *Ground Subtraction: Two Colors as One.*

Figure C–23 *Spreading Effect (Bezold Effect).*

Figure C–24 *Harmony and Saturation.* Top, a reproduction William Morris wallpaper accurately reproduces the muted beauty of the original. Courtesy of Sanderson. Bottom, the exuberance of a saturated palette in a child's wallpaper design from Osborne and Little (Designer's Guild).

Figure C–25 *Harmony and Area.* Small areas of warm color support and emphasize the cool palette around them; at the same time they satisfy the eye's need for equilibrium. This is Elizabeth Eakins' carpet design "Sea Ranch"© 1993 .

Figure C–26 *High-Impact Colors.*

Figure C–27 *Dissonant Colors*. This early-twentieth-century textile design does not appeal to modern color tastes, but was stylish in its day. [1]

[1] Kaleidoscope ornements abstraits composees par Ad.et M.P-Verneuil. Plate 7. Pochoir, Editions Albert Levy, Paris (undated, c. 1929). Collection of the author.

Figure C-28 *Digital Drawing.* Additive color is a perfect medium for illustrating hard surface objects. Drawing courtesy of Professor Ron Lubman, Fashion Institute of Technology.

Figure C-29 *Colors of the 1990s.* Kenneth Charbonneau's assemblage of colors from a multitude of manufacturing sources is a vivid illustration of the colors of a decade.[2]

[2] Courtesy of Kenneth Charbonneau

Glossary

Achromatic Having no discernible hue or color.

Additive mixture Color seen as a result of light only.

Additive primaries Wavelengths of light that must be present to yield white light: red, green, and blue.

Afterimage A "ghost" image generated by the eye in response to stimulation by a single color in the absence of its complement.

Analogous colors Colors adjacent on a color spectrum, sometimes defined as hues limited to the range between a primary and secondary. A group of colors including any two primaries but never the third.

Artists' medium A liquid, paste, viscous, solid, or other base into which pigments or dyes have been introduced to form a transferable colorant such as paint, dye, crayon, or other.

Artists' spectrum The full range of visible hues as organized by Goethe: red, orange, yellow, green, blue, and violet; expandable to include any and all hues in between them.

Bezold effect An effect in which all colors in a composition appear lighter by the addition of light outline, or darker by the addition of dark outline; also an effect in which a colored ground appears lighter because of a carried linear design in light line or darker because of a carried linear design in dark line.

Brilliance The combined qualities of high light-reflectance and strong hue, typically found in saturated colors and strong tints.

Carried colors Colors in an image or design that are laid on the background (*See* Ground).

Chroma A synonym of hue and color; the name of a color (*See* Hue). Also, a term used to describe the *relative* presence of hue in a sample. A vivid color has high chroma, a muted sample has lower chroma.

Color A category of visual experience including hue, value and saturation. Also, a synonym for hue and chroma; the name of a color (*See* Hue).

Colorant A substance that reacts with light by absorbing some wavelengths and reflecting others, giving an object or surface its hue.

Color cycle A period of time or stage in consumer preference for certain palettes; the prevalence of certain colors in the context of a particular time.

Color forecasting A service that provides manufacturers and vendors with information and guidance on upcoming consumer interest in certain colors and palettes.

Color wheel A synonym for spectrum. Also a term sometimes used to mean a circle of color that scientist James Maxwell devised to demonstrate the additive nature of colored light. (Hope 1990, page 201).

Complementary colors Colors directly opposite each other on the artists' spectrum or color wheel. Every pair of complements contains the three primary colors (red, yellow, and blue) in some proportion or mixture.

Contrast reversal A variation of afterimage in which the "ghost" image is seen as a negative of the original image and as its complementary color.

Dilution Changing a pure or saturated hue by lightening, darkening, or muting (or by the addition of black, white, gray, or its complement).

Display mode The way in which a user mixes colors of a monitor light display.

Equilibrium An involuntary, physiological state of rest that the eye seeks out. Equilibrium occurs when all three (additive or subtractive) primary colors are present within the field of vision.

Gamut The full range of colors available in software and seen as the display of a color monitor.

Gray scale Anything that contains intervals of gray as well as black and white, such as a gray scale monitor, which usually displays 256 grays.

Ground The background against which colors, forms, or shapes are laid.

Harmony A pleasing effect. In color, the pleasing joint effect of two or more colors.

Hue The name of the color: red, orange, yellow, green, blue, or violet. Synonyms are chroma or color.

Hue intensity The saturation or purity of a color; its vivid versus dull quality (*See* Saturation).

Incident beam The beam of light that is emitted by a light source.

Intensity Sometimes used as a synonym for brilliance, or the strength of a hue (*See* Hue intensity and Light intensity).

Intermediate color A color on the spectrum between a primary and a secondary.

Interval A visual step between color samples. Even intervals are visually equidistant steps between colors.

Luminosity Literally, light emitted without heat. Used to describe the light-reflecting quality of a color. Luminous colors reflect light; non-luminous colors absorb light.

Maximum chroma The strongest possible manifestation of a hue.

Medium The means by which something is transmitted. (*See* also Artists' medium).

Metamerism The phenomenon that occurs when two objects that appear to match under one set of light conditions do not match under a different set of light conditions.

Monochromatic Containing only one hue.

Monotone Color without variation. Generally used to describe two or more colors of close or identical value and saturation.

Object mode of vision The presence of a viewer, light source, and object.

Optical mix A new color that is seen as a result of the close juxtaposition of small areas of two or more other colors.

Palette Literally, a board or plate upon which colors are mixed. Palette describes a group of colors used characteristically by an individual artist or designer, or in a specific design, group of designs or body of work, or the colors of a particular era.

Pastel An apparel-industry term for colors diluted by white to high or middle value; also, clean tints with little or no muted quality.

Physical spectrum The full range of visible colors of light as postulated by Newton: red, orange, yellow, green, blue, indigo (blue-violet), and violet.

Pigment A colorant that is finely ground and suspended as minute particles in a vehicle. Traditionally, pigments were inorganic (earth colors), but modern chemistry has blurred this definition. Pigments in general are opaque.

Pixel One of the points of light that make up the picture on a computer (or TV) screen. The word is short for "picture element."

Primary colors The simplest colors of the artists' spectrum; those that can not be reduced or broken down into component colors: red, yellow and blue (*See* also Additive primaries and Process colors).

Process colors A subtractive medium that selectively absorbs and transmits light. Yellow, cyan (blue-green), and magenta (red-violet) colorants that when mixed or laid over one another result in nearly all possible colors on the printed page. Used with the addition of black in four-color printing.

Process primaries Cyan (blue-green), magenta (red-violet), and yellow (*See* Process colors).

Pure color *See* Saturated color and Maximum chroma.

Reflected beam The beam of light reaching an object that is reflected back to the eye.

Saturated color The most intense manifestation of a color imaginable; the "reddest" red or "bluest" blue. Saturated colors are undiluted by black, white, or gray. Synonyms are pure color, full color, or hues at maximum chroma.

Saturation The degree of purity of a color; its hue intensity or vivid quality, as opposed to muted or dull quality. A fully saturated color can contain one or two of the primary colors but never the third. Saturated color does not contain any black, white, or gray.

Secondary colors Colors made up of two primary colors. In artists' media, orange (red and yellow), green (blue and yellow), violet (red and blue); in additive mixtures cyan (blue and green), yellow (red and green), and magenta (blue and red); in process colors red (magenta and yellow), green (yellow and cyan), and blue (magenta and cyan).

Shade A pure color made darker, or with black added.

Simultaneous contrast A spontaneous color effect that results from a physiological response of the eye to stimulation by one color only. The eye, seeking equilibrium, generates a "ghost" image that is the complement of the stimulating color.

Single interval The smallest difference between samples that a viewer can distinguish; established by the individual's threshold (*See* Interval and Threshold).

Spectrum The full range of visible hues (*See* Artists' spectrum and Physical spectrum).

Subtractive mixture Color seen as the result of the absorption of light; the colors of objects.

Subtractive primaries The primary colors of artists' media, the artists' primaries: red, yellow, and blue (*See* also Process primaries).

Tertiary colors Colors made of any mixture of the three primaries ; "brown" or chromatic neutrals.

Tint A pure color plus white, or made lighter.

Tone A nonspecific word referring to some change in a hue. Most often used to mean a graying, or reduction in saturation (chroma).

Value Relative light and dark, with or without the presence of hue. High-value samples are light, low-value samples are dark.

The Workbook

General Instructions

Work in natural light whenever possible. If natural light is not available, a combination of incandescent and fluorescent light works well.

Take frequent breaks. The ability to see differences in color declines with eye fatigue.

Using stiff white paper, cut a "viewing paper" for isolating colors that must be compared. A paper about three or four inches square with a center opening about one inch in diameter works well.

Figure W–1 A viewing paper is useful for comparing colors.

Resist "naming" colors. The same color sample may work well as the "answer" to more than one assignment. Approach each problem separately as if it were the first and only one to be done. Never use commercially printed "color wheels" as a reference—use your eyes.

Color papers provide a stable starting point for eye-training. Working from the paper samples allows repeated comparisons from fixed examples, so a single color may reliably be observed in different placements.

Never rely entirely on the *names* on the tubes for saturated colors, even for primary colors. Many colors are better when mixed from combinations of the tube colors.

Students may do some, but not all, of the exercises in the workbook. Each exercise is written as if it were alone, but many assignment are extensions of earlier ones. As you work through the problems, look back to see if you have past work that is a foundation for solving a new problem.

Exercises In Light

L-1. List as many common light sources as you can. Observe the effect of at least four different light sources on the same red sample of paper or fabric. Describe differences in the red under the various sources in terms of hue, value and saturation. Repeat the exercise using a deep blue.

L-2. Cut two stiff rectangles of cardboard about two inches by three inches. Select any color wool yarn except black, white, or gray. Wind the yarn around each piece of cardboard in one direction until the cardboard is completely covered.

Leave one piece of cardboard with the wool wrapped around it. Form the second skein of yarn into a "pom" by removing the cardboard and tying the looped yarn firmly in the center. Cut one end of the looped end of yarn with a scissor to a create flat, cut end. Describe the difference between the flat yarn and the cut end. What is the reason for the difference?

L-3. Select two different materials (like paint and fabric, or carpet and plastic laminate) that appear to be the same color in daylight. Compare them to each other under incandescent and fluorescent light. Describe what you see in terms of hue, value, and saturation.

L-4. Go to any Website. Using color papers, try to "match" the screen colors. Print out the screen image. Compare the colors on the monitor, your "matching" paper colors and the printed page. Describe their similarities and differences in terms of hue, value, and saturation.

L-5. Locate another active monitor. Go to the same Website as above. Repeat the exercise and compare the results from the two monitor screens. Describe similarities and differences in terms of hue, value, and saturation.

Exercises In Hue

H-1. Class exercise in color identification. This exercise requires that each student have the same type pack of silk-screened color papers.[*]

Working alone, select from the color pack the twelve saturated colors of the artists' spectrum. Arrange them in color order, and return all other papers to the box (be sure that the back of each paper has been initialed).

Turn to the person next to you. Using only the two sets of colors already selected, compare your saturated colors. Working together, reevaluate your choices and decide on a single, new set of twelve spectrum colors. Return all rejected samples to the box. There is now one set of twelve saturated colors for each two students.

Turn to the pair of students next to you. Repeat the comparison exercise until four students agree on the same twelve saturated colors. Return all rejected samples to the box. Four students have now agreed on a single set of twelve saturated colors.

Compare each group's selections to the others. Using only those colors already selected assemble a final set of twelve saturated colors.

What happens? Why?

H-2. (A) Illustrate the twelve saturated hues using color papers. Mount them as a strip of equal squares.

(B) Illustrate the twelve saturated hues using gouache paints. Paint them as equal arcs of a "doughnut" color circle.

H-3. Using color papers, select hues moving from warmer to cooler:

(A) Start with saturated blue. Select two more blues in steps moving cooler and two more blues in steps moving warmer, for a total of five samples.

[*] This exercise cannot be done alone. It can be done with two students, but a larger group, up to twenty students, is best.

(B) Start with saturated violet. Select two more violets in steps moving cooler and two more violets in steps moving warmer, for a total of five samples.

(C) Start with saturated green. Select two more greens in steps moving cooler and two more greens in steps moving warmer, for a total of five samples.

H-4. Using color papers:

(A) Select and mount a group of at least five analogous colors. Use saturated hues and tints only.

(B) Select and mount a group of at least five analogous colors. Use muted hues and shades only.

H-5. Create a simple coloring-book type of design. You may leave white as the ground. Make two copies of the design. Using paints:

(A) Select two primary colors. You may use these two colors as pure colors, tints, or shades. Fill in your design, being careful to cover all lines so that colors are blocks or masses without outlines.

(B) Repeat your filled-in design, changing it only by adding a touch of the third (missing) primary in some area.

Show the two designs to someone else. Which colorway does the person prefer? Why?

H-6. Obtain a sample of screen-printed wallpaper. The more colors in the paper, the better.

(A) Using color papers, match each of the print colors in the wallpaper.

(B) Using gouache paints, match each of the print colors in the wallpaper.

H-7. Select a middle gray paper with as little chromatic undertone as possible. Cut

it into six one-inch squares. Select the six saturated hues from color papers. Cut each into a two-or three-inch square. Arrange the colors in complementary pairs.

Work with one pair of complements at a time. Lay a gray square on each color. Describe each gray square in relation to the one that is placed on the opposing, complementary ground.

What are the differences? Why do they occur?

Figure W–2 Charts for seeing afterimage.

H-8. (A) Select the strongest possible red paper or red paint. Make a circle roughly six inches in diameter. Place a small black dot, about one-eighth-inch diameter, in the center of the red circle. Mount the red circle on a larger square of white paper.

Select a second sheet of white paper the same size as the first. Make a black dot about one-eighth-inch in diameter in the center of the paper.

Stare at the red circle as long as possible with blinking. Then blink firmly, once, and look immediately at the black dot in the center of the plain white paper.

What do you see? Why?

(B) Select the strongest possible yellow paper or yellow paint. Make a pattern of connected diamonds, each about two inches across the widest point, on white paper.

Select a second sheet of white paper the same size as the first. Make a black dot, about one-eighth-inch in diameter, in the center.

Stare at the yellow diamonds as long as possible with blinking. Then blink firmly, once, and look immediately at the black dot in the center of the plain white paper.

What do you see? Why?

Exercises In Value

V-1. Select a single, disposable publication (a glossy magazine or newspaper). Use as many issues as you need, but stay with a single publication; the paper and printing ink must be consistent.

Cut or tear photographs from the publication into small strips, scraps or pieces. Using pencil, draw a rectangle about eight by ten inches on a larger sheet of Bristol paper.

Arrange your torn or cut pieces in value order from light to dark. Cover the rectangle completely; overlap your scraps so that no white paper shows through. Scraps can overlap the pencil edge, which will be trimmed later. Glue down using Elmer's glue, white school paste, or rubber cement. Trim the collage into a neat rectangle, and mount on white paper.

Figure W–3 A newsprint collage of ascending values.

Which areas are most difficult to select? Why?

V-2. Illustrate even intervals of value:

(A) Paint a series of even intervals of value in nine steps from black to white. Start with white, and end with black.

(B) Paint a series of even intervals of value in nine steps using orange or red. Start with the palest tint, and end with the darkest shade.

(C) Paint a series of even intervals of value in nine steps using green or blue. Start with the palest tint and end with the darkest shade.

V-3. Select *one* of the following *pairs* of colors:

 Blue and orange
 Green and orange
 Red and blue

Figure W–4 Place the cool and warm colors of equal value on top of each other in the same corners.

Using color papers, select four intervals of value in the warm color of the pair you have selected. Use saturated color, tints, or shades to get four roughly equal value steps. Do not change the hue.

Cut each of the four selections into one square about two or three inches and a second square about half that size. You will have four large squares and four smaller ones; two of each sample.

Select four intervals of value in the cool color that are *equal in value to the four steps of the warm color*. Use saturated color, tints or shades to get the steps that are equal in value to your warm color. Do not change hue.

Cut the four cool colors into squares the same size as the warm colors. You will have a total of eight large squares and eight smaller ones: two of each sample.

Starting with the warm color, paste the large squares in value order (light to dark) as shown below. Start at the top left, and move clockwise. Take the small squares of the cool color, and paste each one over the warm square that is its equal in value.

Repeat, using the cool color as the larger square and the smaller warm color on top.

V-4. Create a simple coloring-book type of design. Make two copies of the design on white paper.

 (A) Using gouache paint, mix four well-spaced value intervals of gray. You may also use black. Using the five values, fill in your design, being careful to cover all lines. The background of your design should be left white.

 (B) Repeat your design, changing the placements of the grays and black. What happens?

V-5. Create a simple coloring-book type of design. Make four copies of the design.

 (A) Paint your design using black, white, and three different values in gray, being careful to cover all outlines.

 (B) Mix five intervals of value in a warm hue. Fill in your design, maintaining the same relative dark-to-light placements of your original.

 (C) Mix five intervals of value in a cool hue. Fill in your design, maintaining the same relative dark-to-light placements of your original.

(D) Select three or more *different* hues. Fill in your design using the different hues, maintaining the same relative dark-to-light placement of the original. Use saturated colors, tints, or shades as needed.

V-6. Using colored papers, illustrate vanishing boundaries.

V-7. Make a chart that illustrates the six spectrum hues (red, orange, yellow, green, blue, and violet) in *equal intervals of value*. Arrange each hue vertically in seven equal steps of value from palest tint to darkest shade. When the completed chart is read horizontally, each hue is the same value.

Figure W-5 Chart equal
values in this way.

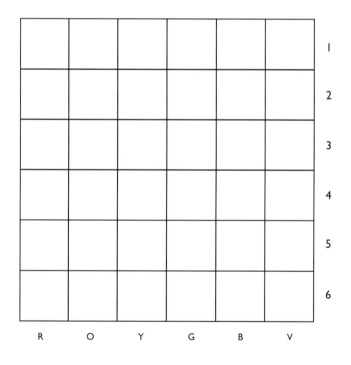

Using the ruler and triangle or other drafting equipment, lay out a grid of squares or rectangles about three-quarter inch by one-and-one-half inches.

Outside the grid and using a soft pencil, label your colors R/O/Y/G/B/V and number the vertical steps one through six.

Cut a number of paper strips for testing and comparing colors. *Retain all of your samples until the entire chart is complete*.

Begin by painting a value series in yellow, being careful to create even intervals. Make a preliminary decision about the placement of the saturated yellow within the series. (The first series usually needs adjusting.) The completed yellow series will be the standard for the chart. Each of the other five hues will be compared to it.

Mix a generous amount of each of the other five spectrum colors to painting consistency. Work with each color separately, always comparing each step to the original yellow value scale. *All hues will not necessarily appear on the chart as saturated colors*. On a chart of six hues in seven steps of equal value, some colors may fit only as tints or shades.

Exercises In Saturation

S-1. Using color papers, select the saturated colors red, orange, yellow, green, blue and violet. Select a gray that is equal in value to each saturated hue.

Working with one hue at a time, find the color that is the middle interval between the pure hue and its gray of equal value. Cut each group of three samples into small squares and mount as a strip.

S-2. Using color paper, select the three basic complementary pairs. Select three even intervals between each pair of complements (a total of five steps, including the two colors at each end). Working with one set of complements at a time, cut the five steps into small squares and mount as a strip.

What is characteristic of the first step next to each pure color? What is characteristic of the middle intervals?

S-3. Create a simple coloring-book type of design. Make four copies of the design.

Mix a generous amount of paint in any pair of complementary colors. Using these two colors and black and white, paint the four identical designs so that they are as different as possible from each other. Use the paints in any way at all—as pure colors, tints, shades, or mixed together.

S-4. Create a simple coloring-book type of design. Make two copies of the design.

 (A) Using gouache paint, paint the design with any saturated colors and tints.

 (B) Repeat the design using the same hues and values, but using muted colors (reducing the saturation).

Exercises In Illusion

I-1. Using color papers, make a single pure color or tint appear to be two different *values* by placing it on different grounds.

I-2. Using color papers, make a single pure color or tint appear to be two different *hues* by placing it on different grounds.

I-3. Using color papers, make a single muted hue appear more vivid and more muted by placing it on different grounds.

I-4. Using color papers, make two *different* colors (of any qualities) appear to be the same by placing it on different grounds.

I-5. Using color papers, make a tertiary color appear to be two different colors by placing it on different grounds.

I-6. Using color papers, create a transparence illusion starting with:

 (A) Two different grays
 (B) One hue in two different values
 (C) Two different pure hues
 (D) One pure hue and any gray
 (E) One warm hue and one cool hue in any values

In each illusion, one color will appear to be on top, the other underneath. Explain why for each example.

Exercises In Harmony and Impact

CH-1. Create a simple coloring-book type of design. Make three copies of the design on white paper. Mix a generous quantity of any three or more saturated colors or tints. This is the base set of colors for this exercise.

Starting with the mixed colors above, make a second set, muting each color by adding its complement in small quantities. If necessary, add white to the new colors so that the values of the muted colors are the same as the originals.

(A) Paint your design in saturated colors and tints.

(B) Paint the design in muted colors, maintaining the same color placements.

(C) Paint the design a third time, maintaining the same placements, but using both "clean" and muted colors.

Which versions are more appealing? Why?

CH-2. Create a simple coloring-book type of design. Make two copies of the design on white paper.

(A) Paint a series of nine intervals of value from black to white. (Exercise V-2, A, can be reused for this exercise.) Number the steps one to nine, starting with the light end. Using steps two, five and eight, fill in your design. Be careful to cover all lines. Leave the background white.

(B) Repeat your design, using steps two, three and eight.

Which version do you prefer? Why?

Figure W-7 Nine intervals of Value.

1 2 3 4 5 6 7 8 9

CH-3 Create a simple coloring-book type of design. Make two copies of the design on white paper.

Select any pair of complementary colors. Create a palette for your design using the two hues in as many steps of value as you wish. Keep the level of saturation uniform: all colors should be either "clean" *or* muted.

(A) Paint your design using one hue (in any values) to cover 80% or more of the design area and the second hue to cover 20% or less of the area.

(B) Repeat, using the two hues as equal areas of the design.

Which version is more appealing? Why?

Just For Fun

F-1 Using gouache paints and block letters (either drawn or from a template), reinforce the meaning of a written word with color. Some possible word selections are:

Razzle Dazzle
Vanishing
Chameleon
Ice Palace
Sunset
Convex (or Concave)

F-2 Illustrate a rounded form, like an apple or pear, using tiny dots of pure color.

F-3 Create a transparence illusion starting with a warm color and a cool color. Manipulate the color of the overlapped area so that the cool color appears to be on top. Do the assignment again, making the warm color appear to be on top.

F-4 Select a palette of colors that represents an emotion.

Bibliography

Albers, Josef. 1963. *Interaction of Colors*. New Haven: Yale University Press, 1963.

Armstrong, Tim. *Colour Perception: A Practical Approach to Colour Theory*. Norfolk, England: Tarquin Publications, 1991.

Arnheim, Rudolf. *Visual Thinking*. Berkeley and Los Angeles: University of California Press, 1969.

Bartlett, John. *Familiar Quotations*. Boston: Little, Brown and Company, 1980.

Bates, John. *Basic Design*. Cleveland: World Publishing, 1960.

Billmeyer, Fred W., and Max Salzman. *Principles of Color Technology*. New York: Interscience Publishers (division of John Wiley & Sons, Inc.), 1966.

Birren, Faber. *Principles of Color*. West Chester, PA: Schiffer Publishing Company, 1987.

Birren, Faber. *Color Psychology and Color Therapy*. New York: University Books, 1961.

Birren, Faber. *Color Perception in Art*. New York: Van Nostrand Reinhold, 1976.

Birren, Faber. *Color and Human Response*. New York: VNR, 1978.

Bowlt, John E., and Carol Washton-Long, editors. *The Life Of Vassili Kandinsky: A Study On The Spiritual in Art*. Oriental Research Partners, 1980.

Chevreul, Michel Eugene. *The Principles of Harmony and Contrast of Colors and Their Applications to the Arts*. New York: Reinhold Publishing Company, 1967.

Cohen, Arthur, editor. *The New Art of Color: The Writings of Robert and Sonia Delaunay*. New York: The Viking Press, 1978.

Cotton, Bob and Richard Oliver. *The Cyberspace Lexicon*. London: Phaidon, 1994.

Crofton, Ian. *A Dictionary of Art*. London: Routledge, 1988.

Crozier, Ray. *Manufactured Pleasures-Psychological Responses to Design*. Manchester: Manchester University Press, 1994.

De Grandis, Luigina. Translated by John Gilbert. *Theory and Use of Color*. New York: Harry N. Abrams Inc., Publishers, 1984.

Designer's Guide to Color, Volumes I and II. Translated by James Stockton.San Francisco, CA: Chronicle Books, 1984.

Eiseman, Leatrice. *The PANTONE Book of Color*. New York: Harry N. Abrams, Publishers, 1990.

Evans, Ralph M. *An Introduction to Color*. New York: John Wiley & Sons, Inc., 1948.

Goethe, Johann von Wolfgang. *Goethe's Color Theory*. Translated by Rupprecht Matthei. New York: Van Nostrand Reinhold Company, 1971.

Goldstein, E. Bruce. *Sensation and Perception*. Belmont, CA: Wadsworth Publishing Company, 1984.

Greenhalgh, Paul. *Quotations and Sources on Design and the Decorative Arts*. Manchester: Manchester Press, distributed by St. Martin's Press, 1993.

Greiman, April. *Hybrid Imagery: The Fusion of Technology and Graphic Design*. London: Architecture Design and Technology Press, 1990.

Hale, Helen. *The Artist's Quotation Book*. London: Robert Hale , 1990.

Holtzschue, Linda and Edward Noriega. *Design Fundamental for the Digital Age*. New York: Van Nostrand Reinhold Company, 1997.

Hope, Augustine and Margaret Walch. *The Color Compendium*. New York: Van Nostrand Reinhold Company, 1990.

Itten, Johannes. *The Art of Color*. Translated by Ernst Van Haagen. New York: Van Nostrand Reinhold, 1960.

Itten, Johannes. *The Elements of Color*. Edited by Faber Birren. Translation by Ernst Van Haagen. New York: Van Nostrand Reinhold, 1970.

Itten. Johannes. *The Basic Course at the Bauhaus, Revised Edition*. London: Thames and Hudson (also Litton Educational Publishing), 1975.

Jenny, Peter. *The Sensual Fundamentals of Design*. Zurich: Verlag der Fachvereine, 1991.

Kandinsky, Wassily. *Point and Line to Plane*. New York: Dover Publications Inc., 1970.

Krech, R, Crutchfield, S., and N. Livison. *Elements of Psychology, Second Edition*. New York: Alfred A. Knopf, 1979.

Labuz, Ronald. *The Computer in Graphic Design: From Technology to Style*. New York: VNR , 1993.

Lambert, Patricia. *Controlling Color*. New York: Design Press, 1991.

Larsen, Jack Lenor and Jeanne Weeks. Fabrics for Interiors. New York :VNR, 1975.

Lauer, David A., and Stephen Pentak. *Design Basics Fourth, Edition*. US: Harcourt Brace College Publishing Company, 1995.

Light and Color. General Electric Publication TP-119, 1978.

Lighting Application Bulletin. General Electric Publication #205-41311, undated.

Linton, Harold. *Color Forecasting—A Survey of International Color Marketing*. New York: Van Nostrand Reinhold, 1994.

Loveless, Richard, editor. *The Computer Revolution and the Arts*. Tampa: University of South Florida Press, 1986.

Luckiesh, M. *Visual Illusions: Their Characteristics and Applications*. New York: Dover Publications, Inc., 1965.

Lupton, Ellen and J. Abbott Miller, editors. *The Bauhaus and Design Theory*. London: Thames and Hudson, 1993.

Mahnke, Frank H. and Rudolf H. Mahnke. *Color in Man Made Environments*. New York: VNR, 1982.

Maier, Manfred. *Basic Principles of Design*. New York: Reinhold Company, Inc., 1980.

Makorny, Ulrike Becks. *Kandinsky*. Koln: Benedikt Taschen, 1994.

Mayer, Ralph. *The Artist's Handbook of Materials and Techniques*. New York: The Viking Press, 1981.

McClelland, Deke. *Mastering Adobe Illlustrator*. Home Wood, IL:Business One Irwin Desktop Publishing Library, 1991.

Munsell, Albert Henry. *A Grammar of Colors*. New York: Van Nostrand Reinhold, 1969.

Nicolson, Marjorie Hope. *Newton Demands the Muse*. Princeton, NJ: Princeton University Press, 1966.

Ostwald, Wilhelm. *The Color Primer*. New York: Van Nostrand Reinhold, 1969.

Pantone, Inc., reprint from October, 1998 edition of *Electronic Publishing*. PennWell, 1998.

Parsons, Thomas and Sons. *Historical Colours*. London: Thomas Parsons and Sons, 1934.

Pocket Pal. Michael Bruno, editor. Memphis,TN: International Paper, 1988.

Poore, Henry R. *Art Principles in Practice*. New York: G. P. Putnam's Sons, The Knickerbocker Press, 1930.

Rodemann, Patricia A. *Patterns in Interior Environments: Perception, Psychology and Practice*. New York. John Wiley & Sons, Inc., 1999.

Rood, Ogden. 1973. *Modern Chromatics*. New York: VNR , 1973.

Sappi, Warren. *The Warren Standard Volume Three No. Two*. SD Warren Company ,225 Franklin Street Boston, MA 02110 #96-5626 ©1996

Sargent, Walter. *The Enjoyment and Use of Color*. New York: Dover Publications, Inc., 1964.

Scott, Robert Gilliam. *Design Fundamentals*. New York: McGraw Hill Book Company, Inc., 1951.

Sharpe, Deborah. *The Psychology of Color and Design*. Totowa, NJ: Littlefield, Adams and Company, 1975.

Shlain, Leonard. *Art and Physics: Parallel Visions in Space, Time and Light*. New York: William Morrow Inc., 1991.

Sloane, Patricia. *The Visual Nature of Color*. New York: Design Press, 1989.

Solso, Robert L. *Cognition and the Visual Arts*. Cambridge, MA: The MIT Press,1994.

Swirnoff, Lois. *Dimensional Color*. Boston: Birkhauser, 1986.

Tanaka, Ikko. *Japan Color*. San Francisco: Chronicle Books, 1982.

Taylor, Joshua C. *Learning to Look*. Chicago: University of Chicago Press, 1927.

The Color Theories of Goethe and Newton in the Light of Modern Physics. Lecture held in Budapest on April 28, 1941, at the Hungarian Club of Spiritual Cooperation. Published in German in May, 1941 in the periodical *Geist der Zeit*. English translation courtesy of Dr. Ivan Bodis-Wollner, Rockefeller University, New York, 1985.

The New Lexicon Webster's Dictionary of the English Language. New York: Lexicon Publications, 1987.

The Random House Dictionary of the English Language. Jess Stein, Editor-in-chief. New York: Random House, Inc., 1967.

Theroux, Alexander. *The Primary Colors*. New York: Henry Holt and Company, 1994.

Theroux, Alexander. *The Secondary Colors*. New York: Henry Holt and Company, 1996.

Tufte, Edward R. *Envisioning Information*. Cheshire, CT: Graphics Press, 1990.

Venturi, Lionello. *History of Art Criticism*. New York: E.P Dutton and Co., 1964.

Verneuil. Ad. Et MP. *Kaleidoscope ornements abstraits*. Pochoir. Paris: Editions Albert Levy, (undated, c. 1929).

Varley, Helen, editor. *COLOR*. New York: The Viking Press Distributors. Los Angeles: The Knapp Press, by Marshall Editions Limited, 1980.

Vince, John. *The Language of Computer Graphics*. London: Architecture Design and Technology Press, 1990.

Walch, Margaret. *Color Source Book*. New York: Scribner, 1979.

Webster's New Twentieth Century Dictionary Unabridged Second Edition. US: The World Publishing Company, 1959.

Weinman, Lynda and Bruce Heavin. *Coloring Web Graphics*. Indianapolis, IN: New Riders Publishing , 1996.

Wolchonek, Louis. *The Art of Three-Dimensional Design*. New York: Dover, 1959.

Wolchonek, Louis. *Design for Artists and Craftsmen*. New York: Dover, 1953.

Wolff, Henry. *Visual Thinking: Methods for Making Images Memorable*. New York: American Showcase Inc., 1988.

Wong, Wucious. *Principles of Two Dimensional Design*. New York: Van Nostrand Reinhold Company, 1972.

Index